A NANTUCKET EXPERIENCE

A Year in the Life of a Wash Ashore

SHELLIE DUNLAP

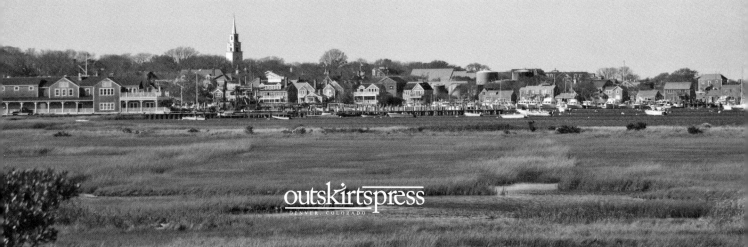

outskirtspress
DENVER, COLORADO

CONTENTS

January, 1

February, 11

March, 21

April, 33

May, 43

June, 53

July, 63

August, 75

September, 87

October, 97

November, 109

December, 119

Foreword

As two long time island summer residents, we are no strangers to the Nantucket experience. Our families have decades of memories and are creating wonderful new ones each year; from beach picnics to Lighthouse hugs to 'Sconset weddings. As meaningful as our time spent on Nantucket is, we know there are many happenings that take place when we're away and we long for a glimpse of island life in our absence.

In her first compilation, Shellie Dunlap vividly depicts the imagery and spirit of Nantucket throughout the year. Her ability to create colorful word pictures, her unique writing style and fresh perspective captures the true essence of the island.

A Nantucket Experience gives every reader a first hand account of a year of island life. Shellie's personal reflections could be ours or those of our friends and neighbors. The book will make you laugh, tug at your heartstrings and will leave you eager to create your own Nantucket experience.

Betsy Grubbs and Caroline Weymar

JANUARY

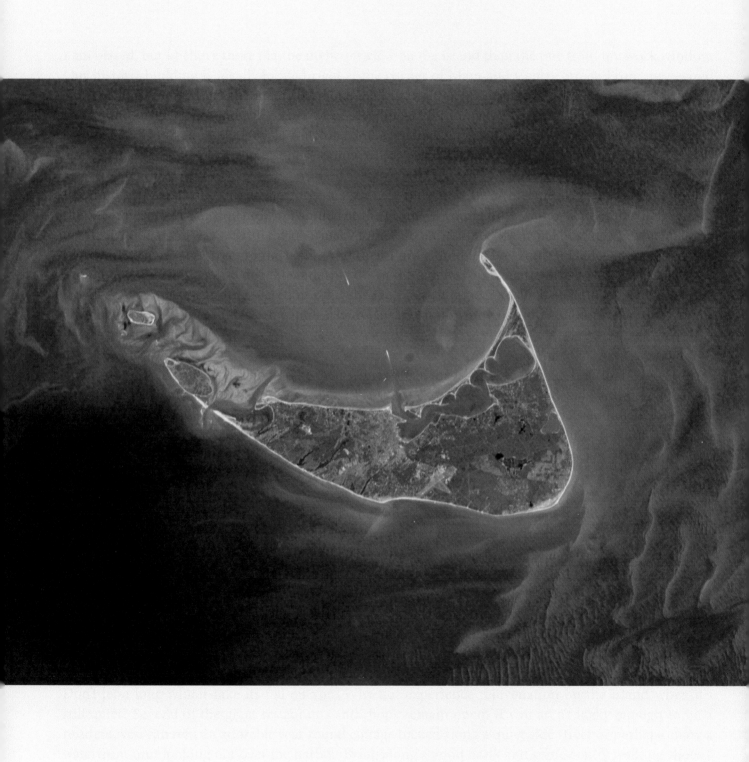

Destination – ACK

I'm a huge fan of the phrase "it's all about the journey." I love a good adventure as much as the next guy (or gal as it were). However, every now and then it really is much more about the destination than the journey. Traveling to Nantucket tends to consume our thoughts with visions of that Kodak moment when we round Brant Point and get our first wide angle glimpse of the harbor...and know we've come home. Getting here is no easy feat - and some days, when Mother Nature is showing off, it can seem almost impossible. But, that's just part of the charm and intrigue that makes this little body of sand so desirable isn't it?

For years, as friends have journeyed miles to come vacation with us in the summer, they have joked that it takes "planes, trains and automobiles" (not to mention boats!) to get here. But once on island, travels are instantly forgotten as the romance with this faraway gem begins. Nantucket is one of those unique places where visitors and residents alike share a common affection. We love this island. Just look around as you walk down the street. Visitors proudly display the name Nantucket on t-shirts and baseball caps, bumper stickers and shopping bags. The island airport code - ACK - is often used as a term of endearment. You can find it stitched on throw pillows and beach towels and splashed on store windows, taxi cabs and stationary.

What is it about this destination that is so seductive? Perhaps it is the fact that there are so many captivating destinations within the destination. We go "out" to Madaket to watch the sunset and "over" to Madequecham to fish. We stop "by" Brant Point to watch the boats come and go and we head "across" the island to Cisco to marvel at the surfers braving the crashing waves. The possibilities for "wow moments" are endless and the opportunity for daily adventures infinite.

My family and I have owned a home here for twenty years, but just recently became year round residents. As a new year-rounder, I've been thinking a lot about all the amazing attributes of Nantucket and recently asked my colleagues if they ever lose the wonder of the island in their daily routines. Do they ever tune out the ferry blast announcing its departure or grow numb to the sense of awe as the fog crawls up Main Street? They all agreed - it is always there...the magic of this place. They assured me the romance won't end anytime soon.

So whether you are from Nantucket and planning a trip away or enthusiastically planning your first trip to the island, just remember that whatever the journey holds to get you here, there is a spectacular destination waiting to greet you when you arrive.

Welcome home!

Hibernating?

I am biased, but I believe there may be no better view on the island than the one from my work window. Our historic building is ideally located right at the corner of Main and Centre Street. From my second story vantage point, I get the luxury of looking all the way up Centre Street right at the Jared Coffin House and if I peek around the corner I can see almost all the way down Main. I confess, at times it's easy to get distracted by the people-watching and island activity as my window beckons me to sneak a glance outside. Some days, you just never know what you might see.

Recently, as I sat gazing out at the gorgeous sunny winter day, I was mesmerized, as I always am, by the sheer beauty of our downtown. I smiled at the group of young boys, out of school for their winter break, making their way over to the pharmacy for ice cream. I noted the usual business people making their daily trip up the street to the bank. And then I did a double take. At first glance it appeared like a giant dog. But this was no dog. Meandering down the sidewalk on Centre Street was a deer...a REAL live deer. She wasn't running scared nor did she look lost. It appeared she had simply decided to take advantage of this quiet mid-week winter day to pay a visit downtown. I kid you not folks, you cannot make this stuff up.

I'd heard the week the local schools take their winter break the island can become a virtual "ghost town." Sure enough, as if on cue, there was a mass February exodus as bright-eyed kids and parents alike, loaded with skis and sleds or beach bags and surfboards boarded planes and boats and made their way to their favorite winter vacation spot. But the island became less of a ghost town in their absence and more of a very sleepy haven, where those of us left behind had the opportunity to experience the island in her raw glory - deer and all!

During these off-season months, the normally bustling streets in town become virtual walking paths. I love to slip away during my lunch hour and wander up and down the sleepy side streets. More than one winter evening, I've left work to discover mine was the only car parked on Main Street - imagine! Some early mornings I walk my dog to the beach and never see another human being. The island often feels like a giant sanctuary. Friends have asked if my husband and I feel isolated or lonely here on this little rock in the middle of the Atlantic as the winter wears on. I assure them it's just the opposite - the quiet season provides a time of nurturing and refreshment. The fresh ocean air and sheer beauty of this place are inspiring and invigorating. The opportunities to explore and experience all she has to offer are endless.

Don't let a long winter take its toll on you. Why not experience rejuvenation on the island when it's still quiet? Several of the great restaurants and shops remain open. If you aren't lucky enough to be a resident, you can rent an adorable year round cottage tucked along a quiet side street or perhaps enjoy a waterfront unit looking out over the harbor. Bring along a good book and some comfy walking shoes - and don't forget your camera. You just never know what you're going to see here in paradise.

Oh deer...

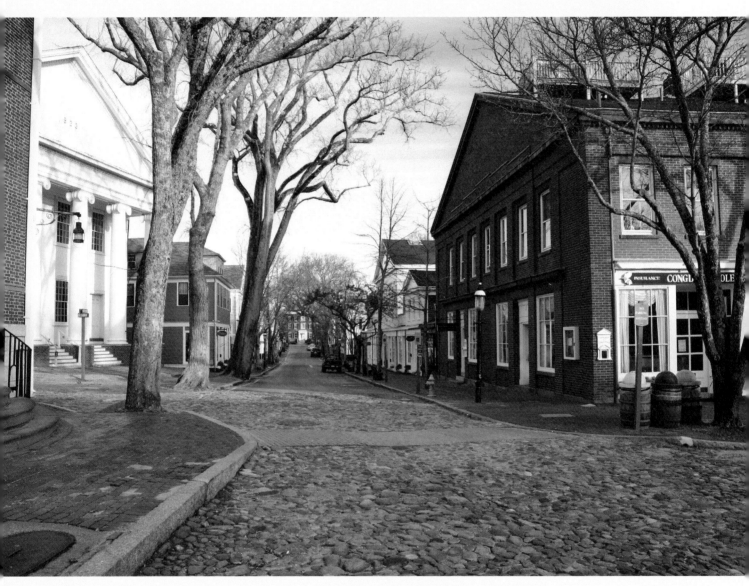

Centre Street in the Off-Season

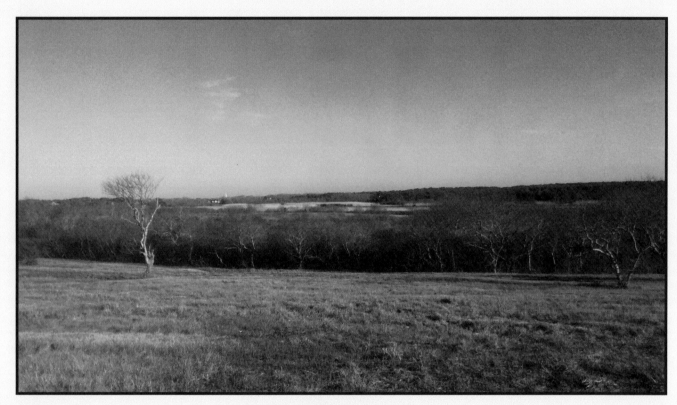

Sanford Farm

A Little Bit Country

Sometimes it is hard to believe it's the dead of winter on Nantucket when the temps are mild and precipitation is light. People island-wide clamor to find activities they can enjoy outdoors. Despite what the calendar says, there are winter days when the bike paths are bustling with cycling enthusiasts, joggers and the occasional roller-blader. The side-streets near downtown are a popular location for the power walkers. But some of the most desired destinations during the beautiful winter days are the out of the way places where winding dirt paths and obscure trails lead to some of the islands best kept secrets. Although downtown is quiet during the off season, locals and visitors enjoy an opportunity to break from their weekly work routines and "go to the country" on the weekends in search of peace and solitude.

Even on this tiny body of sand there are plenty of options for those seeking a little dose of country life. One brisk winter weekend my husband Dan and I, with Coco the white dog in tow, headed to Sanford Farm for a long walk, some quiet reflection and the opportunity to breath in giant gulps of oxygen. I love the topography and winding paths at the farm during every season, but there's something special about experiencing it in the dead of winter. Stripped of its multi-colored hues and lush foliage, it beckons visitors to "come as you are" and celebrate the simplicity of the island in the off-season.

As we walked along we spotted a variety of birds in the trees and bushes, an osprey nest perched high on a post and a couple of deer in the distance. We ran into friends, neighbors and a couple of colleagues as we navigated the winding trail. But even with the few random encounters, it felt like we had the wide-open space mostly to ourselves. We stopped along the way to sit on a bench near the barn in Ram Pasture. My husband's ears enjoyed a quiet sabbatical as we embraced a few golden moments of pure silence. No reason to rudely interrupt Mother Nature's majestic display of beauty with casual conversation.

Nantucket sparkles in the summertime when everything is in full bloom, the stores and restaurants are all open and the streets are bustling with enthusiastic visitors. But the Grey Lady is perhaps her most beautiful in the dead of winter; stripped down to her bare bones, residents and visitors are able to glimpse the very soul of the island. When visiting the island in the off-season, plan to bring along some good books or a journal, rent a home with a fireplace and pencil in plenty of time to head to the "countryside" for long walks and quiet reflection.

Take a hike.

Dinner and a Movie

When the pace slows and the "events" calendar is a bit light, there is still no shortage of things to do on any given night on Nantucket. Many of the restaurants remain open showcasing winter specials. The Atheneum offers weekly lectures, documentaries and specialty classes. Listen to Blues, try your hand at island trivia or step up to the Karaoke microphone at one of the local pubs. For those who love to spend a cold winter night with a piping hot bucket of popcorn viewing a newly released Hollywood flick, the Starlight Theatre is the place to be.

This Nantucket mainstay has long been famous for its "old school" charm and cozy accommodations. With only ninety seats and a 35mm projector, guests are invited to step back in time and embrace days gone by – even as they view newly released films. The charm is enhanced as patrons enjoy a favorite libation (or two!) and a nice dinner on the quaint enclosed patio prior to entering the theater. The local ownership's commitment to excellence is evident in everything from the menu (which features a little something for everyone) to the wait-staff (who are relaxed, attentive and knowledgeable).

One blustery January night, some friends and I met for "dinner and a movie" at the Starlight. The experience reminded me of winter evenings as a kid growing up in small town Iowa. Our theater there was smaller (only fifty seats) and we weren't lucky enough to have an adjoining restaurant for pre-movie dining…but the overall feel was the same. Stepping out for a night of entertainment in a small town is always a bit like old home week. You are almost guaranteed to run into friends and neighbors turning the evening into an impromptu social event. Our night out was no exception. We dined alongside other friends and neighbors, chatting with most everyone in the little restaurant. As we made our way into the theater prior to show time, we stopped to chuckle at the sign posted just outside the curtained entrance. "No Gum Allowed." Guests are welcome to bring their favorite beverage and even the doggy bag with dinner leftovers inside the theater – but leave that chewing gum at home. I love small town life.

With the newly renovated Dreamland Theater now open again, Nantucket is one lucky little town to have two theaters where residents and visitors have the opportunity to step out for a night at the movies. The theaters compliment one another; each offering their own brand of charm and entertainment. Make the movie theater experience part of your Nantucket itinerary. Come prepared to enjoy the quaint facilities, view the current feature and stick around after the show to stage your own Siskel and Ebert "At The Movies" review with local friends and neighbors.

Lights, Camera, Action!

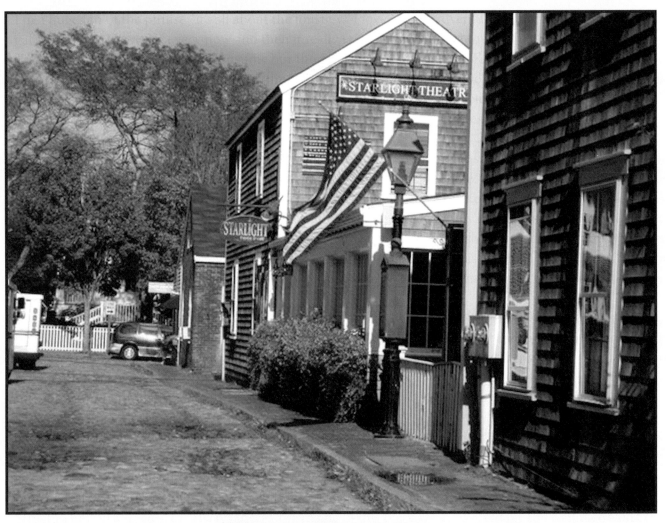

Photo courtesy of Starlight Theatre

FEBRUARY

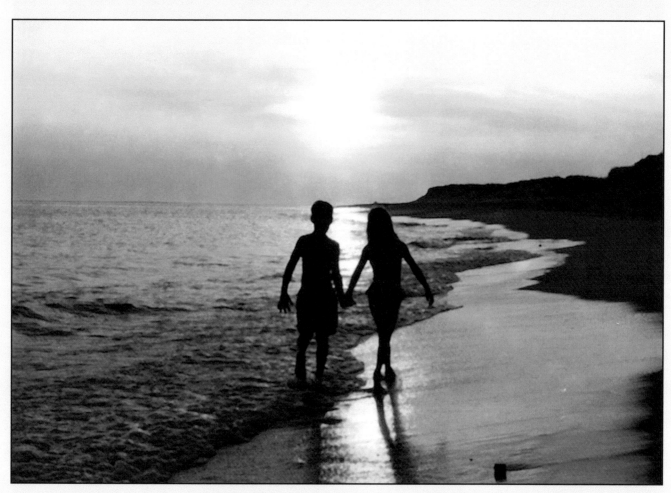

Drew Dunlap and Megan Salonga age 8

Seasons of Love

Seasons of Love, the Act Two opening number in the Broadway blockbuster RENT, poses the question "How do you measure a year in the life?" Jonathan Larson, the composer, suggests the 525,600 minutes in our year should be measured in *"daylights and sunsets and midnights and cups of coffee...in inches, in miles, in laughter and strife"* but concludes with the ultimate challenge to *"measure your life in love."*

When Valentine's Day approaches on this romantic little island, I find myself contemplating how I've measured my life during the 20+ years I've spent, first visiting, and then living here. No question, it's easy to tie many of my families Nantucket memories to a location...a beach, a restaurant, a friend's front porch. But when I really stop to think about it, all the memories that count are the ones I've spent with the people I love...friends and family.

The photo opposite was taken several years ago on a balmy summer night at sunset on Madaket Beach. Our son Drew was eight years old at the time and he and my best friend's daughter Megan slipped away from our picnic to take a little stroll along the water. This image beautifully captures the love our two families share. To this day I cannot step onto the sand in Madaket without remembering that night and thinking about all the memories our families have experienced together.

I'll bet many of you have similar photos in your scrapbooks...images that take you instantly back to an enchanting vacation spot or celebration with your loved ones. Maybe you are just in the process of creating brand new Nantucket memories. Perhaps, like me, you are fortunate enough to call this storybook island home where you are able to measure your life in Nantucket minutes.

Whatever your circumstance, don't miss the opportunity to create some unforgettable Nantucket memories with your loved ones. And by all means, don't miss the "daylights and sunsets and cups of coffee."

<p align="center">How about love?</p>

Sweet Inspirations

Forrest Gump was on my mind recently as I spent some time in the Sweet Inspirations chocolatier on Centre Street. If Forrest had been there with me he likely would have modified his famous line – "Life is like a box… or bag…or Sailors Valentine filled tin – of light or dark chocolates." Sweet Inspirations is like life in this way – you just never know what sweet surprises await you.

I love stopping by Sweet Inspirations any time of year, but it's particularly festive as a holiday approaches. With Cupid's arrow aimed toward Valentine's Day, the shop is decked out in red and pink décor showcasing plush heart-shaped containers brimming with a wide variety of succulent items. Shoppers are invited to purchase the pre-filled containers or customize a special red velvet heart with their favorite confections.

With so much to choose from, I'm glad I set aside significant time to linger in this sensory wonderland. The world-class ingredients used in the chocolates are paired perfectly with the extraordinary customer service provided to visitors. As I peruse the glass case and consider my options, a friendly sales person approaches toting a Nantucket basket filled with plump cranberries expertly dipped in the renowned chocolate. These Cranberry Creations™ are one of their best sellers. She scoops a few onto a spoon and asks with a warm smile, "light or dark?" I savor the little light chocolate ones while I shop.

Nantucket, in all its glory, is on display throughout the store. Island shaped "lollipops," chocolate Nantucket bay scallop shells, sea-mist almonds and Coco the Whale™ truffles (with a red heart shaped "spout" in honor of Valentine's Day!) fill the glass cases. Local artist, Barbara Cappizo, was commissioned to design the beautiful gift tins, the most recent a Sailor's Valentine creation featuring seashells she collected along the Nantucket beaches.

The Sweet Inspirations artisans hand-create most of the tasty morsels in-house every morning. Pecan turtles, mini cranberry cheesecakes, butter-crunch delights and sea-salt roasted almonds beckon me to add them to my little tin. One of my all-time favorite delicacies is the malted milk balls. Light, crunchy and delicious, these bad boys have no problem standing alone as a post dinner treat…but chase them down with a nice red wine and it's a party in your mouth. Always a favorite with a crowd, they've become a mainstay at our dinner parties and large events – given as favors at our second son's engagement party and door prizes at a friend's baby shower.

In honor of Valentine's Day, I veer off course momentarily and consider the thoughtfully wrapped gift bags brimming with red hots or little candy hearts embossed with sweet nothings. I smile and recall memories of third grade Valentine's exchanges as I read "Be Mine!" and "U&Me4Ever" on some of the little hearts. There's nothing like a candy store to bring out the kid in all of us.

If you're lucky enough to be on Nantucket on Valentine's Day, be sure to stop by Sweet Inspirations for a box or bag of your favorite confections. If not, whenever you're on the island, pencil in a stop or two at the chocolate paradise where you too can tap into your inner child. I luv ACK!

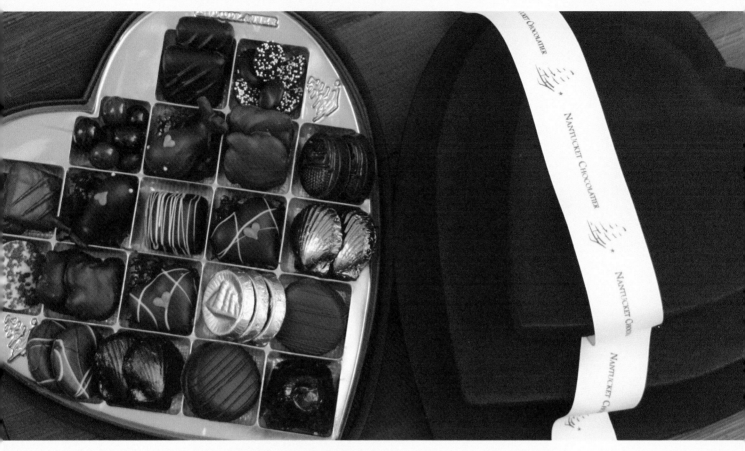

Photo courtesy of John West at Sweet Inspirations

Starry Starry Night

It is no secret that the star laden skies over Nantucket Island are like none you will find anywhere else in the world. Some weeks I literally gasp out loud as I step out of my car in the evening and find myself blanketed with a gazillion twinkling lights. I don't understand the science of it all, but for some reason in the dead of winter the stars appear lower in the sky. It's like Mother Earth, with hand on her hip, tilts just so…as if to say, "look what I'm serving tonight!" Some evenings, when I step out onto the balcony off my bedroom, I kid you not, if I stand on my tiptoes I can almost reach up and snatch one of those little sparklers right out of the sky.

A good friend, with a beachfront home in Madaket, told me once that he feels like the stars are so low he can actually see them dancing right on top of the water. And when one falls from the sky, he can almost see it dip beneath the sea. It is an awe-inspiring phenomenon.

On a recent Friday night I had the privilege of getting an even closer look at this star spangled Nantucket sky. My husband and I visited the Maria Mitchell Observatory for the first time. How could I have been coming to Nantucket for so many years and missed something so spectacular?? As we peered through the tiny lens of the 103 year old (yes, you read that right) telescope, we got an up close and personal look at Jupiter and three of her moons (one had slipped behind her prior to our arrival) and an even closer look at the craters on the moon. The highlight of the night was when Vladimir, our brilliant tour guide, was using his laser pointer to highlight the Belt of Orion in the night sky. As if on cue, a star burst open and soared clear across the sky. We all oooo'd and ahhhh'd with delight.

We have a tradition with our family and friends of making at least one nighttime trip to the beach each summer…for the sole purpose of engaging the stars in a celestial conversation. We bring our flashlights and large quilts and make our way to the nearest sandy beach late in the evening on a bright starry night. As we lie there together, friends or family, we laugh and chat and make bets who will see the first falling star…a game someone always wins! And then as a few moments pass we find ourselves in silence. There is something about lying prone next to the ocean's edge under a blanket of endless glistening lights that brings you face to face with your smallness.

The next time this little island graces you with one of her brilliant starry nights, grab a quilt and a flashlight and someone you love and head to the waters edge. Spend some time absorbing the vastness of it all. And by all means don't forget to make a wish! Nantucket is famous for making people's dreams come true.

Star light…star bright…..

Free as a Bird!

In the words of the illustrious John Lennon, "Free as a Bird, It's The Next Best Thing To Be, Free as a Bird." Those words are never truer than on Nantucket. At any one time this island is filled with dozens of different bird species. In the last days of winter, with all the foliage still missing from the trees and shrubs, areas of conservation land or even our own backyard look like an artists paint palette with brightly colored birds dotting the branches. Just the sight of the Blue Jays, Cardinals and Yellow Finches out my kitchen window make me smile and sets the tone for a happy day.

I've always loved the birds on Nantucket. There is just nothing better than waking up to their sweet singing voices on a slightly cool summer morning. Who among us doesn't ooohh and ahhhh when we see a flock of geese soar overhead or watch the hummingbird feeding outside our window? And it's not just the little tame guys that make me smile. A few weeks ago I was walking my dog to the beach when I spotted what appeared to be an oversized statue perched on the end-post of a split rail fence. As I got closer, I realized this was no statue. It was a real live Red Tailed Hawk – big as life! His body didn't move as I passed, but those immense eyes followed me (you saw this one coming) like a hawk! I'm sure I imagined it, but I could swear he winked as I made my way past.

This hawk encounter and the lovely birds dotting my backyard got my curiosity up. I discovered recently that "birding" is more than just a hobby on this little island. There are folks here who passionately and seriously track the thousands of birds who call Nantucket home or just stop by to pay a visit. Recently, my husband and I decided to tag along with the Nantucket Bird Club early on a bright Sunday morning. I had no idea what to expect, but was delighted by what I found.

This bird watching and tracking is serious business. Twelve of us made our way to several different locations on the island. We spotted Ruddy Turnstone's, Carolina Wren, Yellow-rumped Warbler's and American Oystercatcher's to name a few. Forty-one species in all! I learned more in two hours than I could possibly imagine. Did you know that Brant Point is named for the Brant Goose? Or that some Oystercatchers carry a band on their upper thigh so birders can track their migration?

If you have never had the pleasure of being introduced to the many varieties of birds on Nantucket, I highly recommend you take some time to get acquainted with them. Visit the Edith Andrews Ornithology Collection at the Maria Mitchell Association or check out the programs for kids and adults at the Linda Loring Nature Foundation. Maybe you'll be lucky enough to spot a Black-Capped Chickadee or a Yellow Bellied Sapsucker! (I double dare you to say those names out loud and not smile.) It's fun to learn their names and how to recognize their various singing voices. Throw on some comfy shoes, grab a pair of binoculars and…

…come fly away!

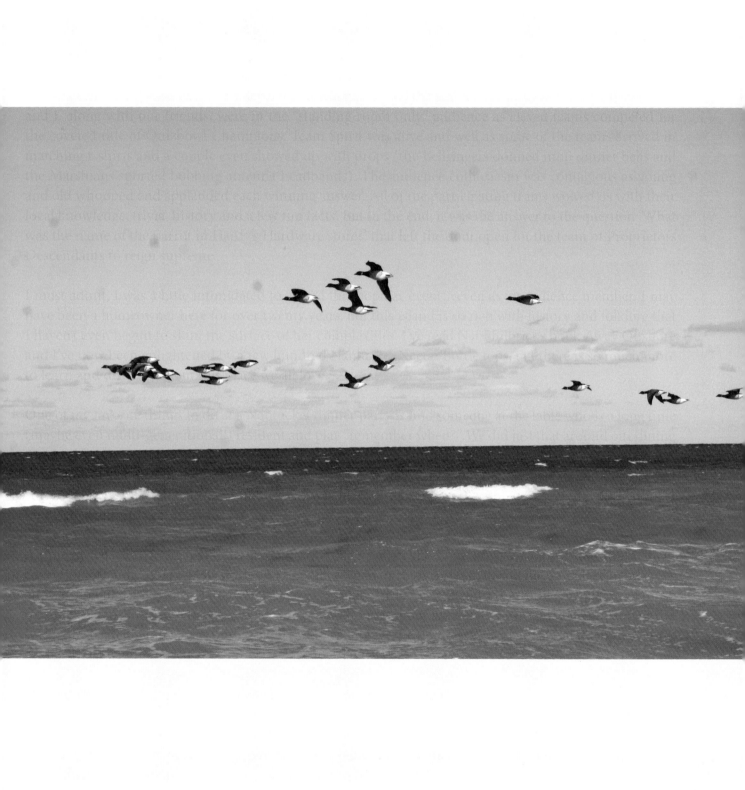

MARCH

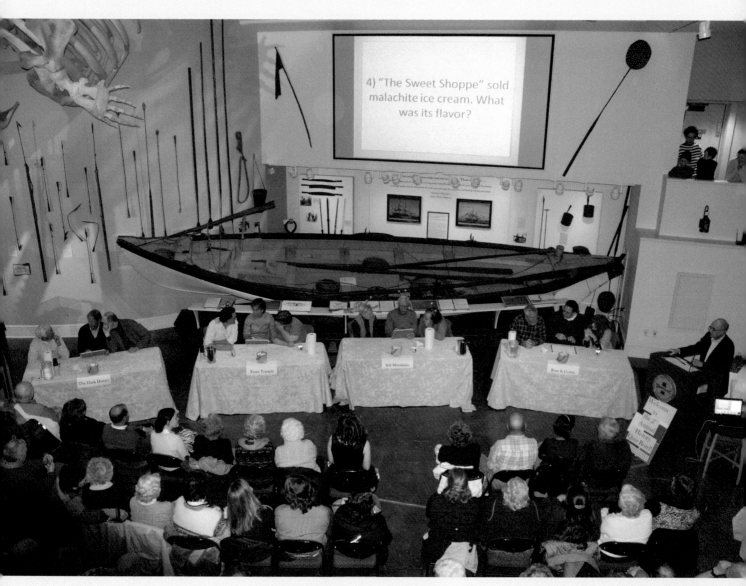

Annual History Quizbowl

Remember When...

The people of this island never cease to amaze me with their creative ability to gather people together for the sole purpose of engaging in good clean fun. On a recent March Saturday night, the Nantucket Historical Association outdid itself in the fun department when it hosted the Annual History Quizbowl. My husband and I, along with our friends, were in the "standing room only" audience as eleven teams competed for the coveted title of Quizbowl Champions. Team Spirit was alive and well as some of the teams arrived in matching t-shirts and a couple even showed up with props (the Bellringers donned mini dinner bells and the Marshians sported bobbing antenna headbands). The audience enthusiasm was contagious as young and old whooped and applauded each winning answer. All of the participating teams wowed us with their local knowledge, trivia, history and a few fun facts. But in the end, it was the answer to the question 'What was the name of the parrot in Hardy's Hardware store?' that left the door open for the team of Proprietors Descendants to reign supreme.

I must admit, I was a little intimidated to attend this popular event…even as an audience member. I may have been a homeowner here for over twenty years, but this island is so rich with history and folklore that I haven't even begun to skim the surface of her complexities. I've read Nat Philbrick's book Away Offshore and I've now been enlightened by a few hundred Nantucket Nectar bottle tops, but there is so much more to learn and discover about this place we all love.

One of my favorite things to do at a Nantucket dinner party is find someone at the table who is a long time (maybe even multi-generational!) resident and play "remember when?" We did just that around our dining room table one snowy evening. Friends shared stories about Saturday nights gone by at the Opera House, retail days at The Country Store and local tales from over the years about the railroad system that used to run from Surfside to downtown Nantucket. I was like a little sponge…I wanted to soak up all their local knowledge and stories.

Although I haven't lived here long enough to compete with the Quiz Bowl champs, I do have a small collection of "remember when" stories. I remember when my kids were small and the best place to buy toys and a gallon of paint was at Hardy's Hardware on Water Street (yes, I met that parrot!). Anyone recall those frosting coated cinnamon twists at the Espresso Café? How about movies at the original Dreamland or the Gaslight Theater before it was the Starlight? Who can forget the flourless chocolate cake at the India House or the award winning fried zucchini sticks at the Atlantic Café?

How about you - what are your favorite Nantucket "remember when" stories? Maybe you'd like to organize a team and come join the Quiz Bowl mania some year. If you're intimidated like me, perhaps you could plan a fun winter weekend to come sit in the audience and cheer along as the local "whiz kids" go head to head. If you're lucky enough to be around a dinner table with Nantucket locals any time soon, by all means invite them to play "remember when" and prepare to be delighted.

By the way….BINGO was his name-o!

Where Everybody Knows Your Name

Who can forget the classic scene in the 1980's famed sitcom Cheers when Hillary Norman Peterson (yes, that was his character's full name!) would burst through the front door and everyone in the building would erupt into a resounding "Norm!" That guy had to feel like king of the bar.

It's comforting to be known by name isn't it? As a fairly new year round resident, one of my favorite things about settling into Nantucket has been the opportunity to meet new friends and neighbors…to learn their names and for them to learn mine. Slowly, I'm beginning to put names and faces together. Others are much better at it than me. The girls behind the Nantucket Pharmacy counter greet me by name, the nice customer service girl at the bank is always ready with a personal hello and even the girls at Holdgate's Laundry now pull those shirts off the rack without asking for my phone number.

During the quiet season, it's always a great opportunity to become friendly with the local business and restaurant owners. Friday nights at Fifty-Six Union are fun because we get to chat with Peter and Wendy the owners and Rose, Liz and Ben the outgoing bartenders who now know both my name AND my favorite cocktail! It goes beyond idle chatter. They inquire about our kids and we love hearing stories about their new puppy and their families. Sunday afternoon's we pop into Fog Island for a coffee or light brunch and spend some time catching up with our favorite waiters.

Adults aren't the only ones who become known by name here. Years ago when our daughter Ashlie was just five years old, we arrived on the island in early June. We hadn't been here since the previous August. Ashlie insisted we stop in to her favorite spot, Aunt Leah's Fudge, to grab a "snack" before heading home. In true Aunt Leah fashion, she greeted us with a warm smile from behind the counter. And then she said, "Hi Ashlie, how was your winter?" Yes, I am aware this is really sick and wrong that my daughter has island notoriety at the local fudge shop. Apparently, she had spent the previous summer frequenting the store on her many trips to town with her brother. The good news is, because of Ashlie's consistent loyalty over the years to Aunt Leah and her fudge, my husband and I are also on a first name basis when we visit the shop. We're "Ashlie's Mom" and "Ashlie's Dad!"

Names are part of Nantucket's heritage. Businesses and streets still proudly bear the names of some of the original proprietors. House names are boldly displayed on a quarterboard above the front door. Virtually every boat in the harbor nobly displays her name for all to see. Even many of the menu items and cocktails at the local restaurants boast fun island names.

So, if you would like to get away and come to a place where *"troubles are all the same and they're always glad you came"*, come spend a few weeks (or a lifetime!) on Nantucket *"where everybody knows your name!"*

Cheers!

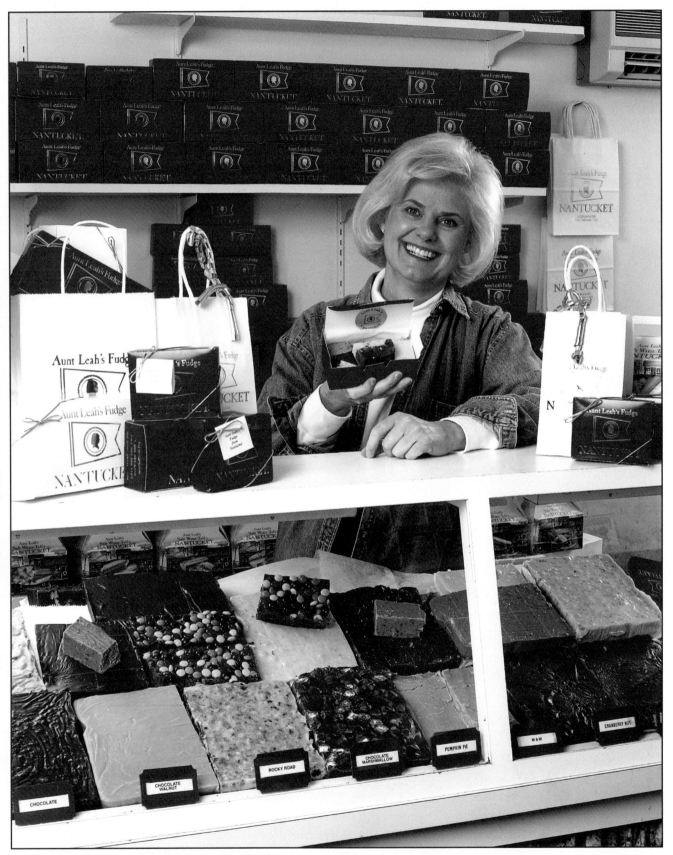

Photo courtesy of Aunt Leah, photographer Jack Weinhold

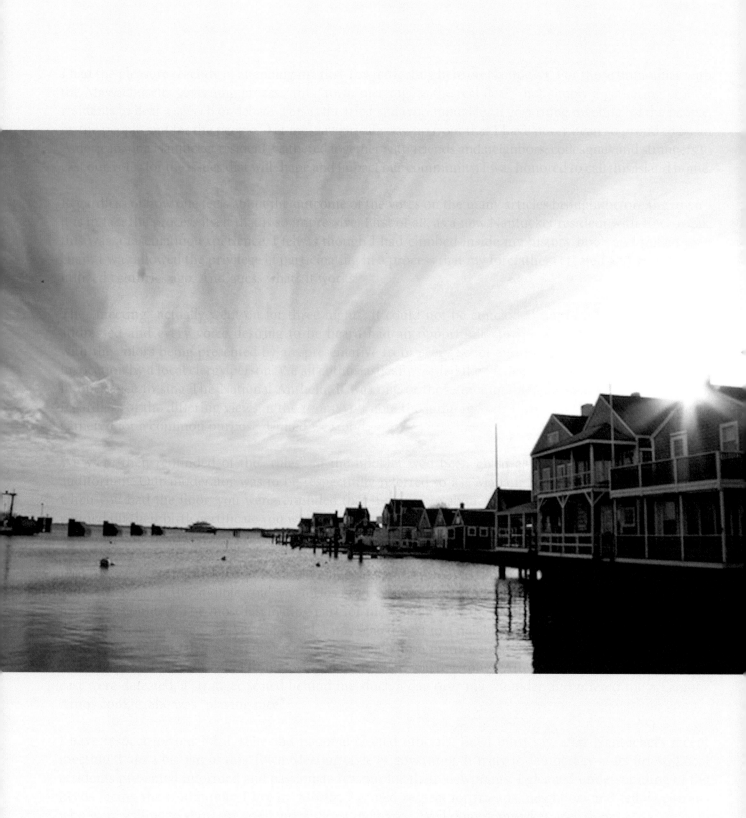

The Dock of the Bay

Before I launch into this, let me clarify I do know the difference between a bay and a harbor (sort of). Regardless, you simply cannot pull up a bench and gaze out at the Nantucket Harbor without Otis Redding breaking into song in your head. I've often wondered what it would be like to slide onto one of those dock-side seats just as the sun is coming up and not move *"until the evenin' comes."* I realize hunger pains and Mother Nature calling might throw up some obstacles, but it would be fun to try anyway.

Don't tell my boss, but I did steal a few priceless minutes to sit harborside recently. I grabbed a little basket of delectable clams from Sayle's Seafood, then strolled along the harbor back into town where I found a bench I was certain had my name on it. I'm not sure why "wastin time" gets such a bad rap. When Otis sings it, I'm reminded that a few introspective moments spent gazing at the water is actually time well spent. I returned to work refreshed, energized and inspired.

I love the Nantucket Harbor in the summertime - all those boats bobbing on their moorings, the ferries coming and going, the Rainbow Fleet splashing color across the water's surface as they glide along. It is fun, festive and looks like one big party on the water as you span the horizon on any given day.

But there is also something mesmerizing about this little safe haven in the off-season. The sheer emptiness of it creates a calm and peaceful sensation - even during the rough storms when there are whitecaps inside. It doesn't always behave peacefully as sometimes the high tides can force water up and over the seawall and even onto the lower streets in downtown. But most days the water just lazily laps up to the docks and some days it seems to almost stand still. One recent winter morning, my husband and I came downtown for an early coffee and grabbed a front row seat on one of the harbor benches. The water was perfectly calm and smooth as glass. We watched the first Hyline round the corner - and then "we watched it roll away again." Ahhhhh.

I also love the unique personality the harbor has from different vantage points around the island. Many of the beautiful homes have front row views of the dotted sails, church steeples, Brant Point Lighthouse and ferry boats. Some, like the wharf cottages, feature decks and docks that reach right out onto the water. Others, like some on Orange Street, boast expansive elevated views of the entire harbor.

Whether you are a homeowner or a tenant, a visitor or a Nantucket local, why not put some time on your calendar to pull up a bench dockside to let the harbor charm you. Watch the boats roll in, observe the tide rolling away and when your Blackberry friends inquire what you're up to, smile and respond...

"wastin time."

United We Stand

I had the pleasure recently of attending my first Town Meeting here on Nantucket. For those unfamiliar with the Massachusetts governing process, this "town meeting" is the real deal - not simply a gathering of local residents to hear a speech or debate. This is the tried and true annual local governing meeting "of the people, by the people and for the people." Let me categorically say up front that I have never been so proud to be an American, or a Nantucket resident. Gathered together with friends and neighbors, colleagues and strangers to cast our votes for the issues that will shape and impact our community, I was honored to call this island home.

Regardless of how one feels about the outcome of the votes on the many articles brought before the town - it is in fact the process itself that is so impressive. First of all, as a new Nantucket resident with Iowa roots, this was a fascinating experience. I felt as though I had climbed inside my history book and pulled up a chair. I was allowed the privilege of participating in a process that my forefathers created and passionately utilized centuries ago. And guess what? It works!

The "meeting" actually went on for three nights. It could not be concluded until each article had been addressed and every voice desiring to be heard had an opportunity to speak. It began ceremoniously with the colors being presented by a representative from every Scout and Brownie Troop. There was an invocation by a local clergy person. We all enthusiastically recited the Pledge of Allegiance and then joined in one voice to sing The National Anthem. It was one of those memorable and sacred moments when, regardless of the differing views in the room, you note the lump in your throat and recognize you are all gathered for a common purpose. United we stood.

We were then reminded of the "rules" in the booklet we'd been given as we entered the high school auditorium. Our moderator was to be respectfully referred to as "Madam Foreman." Most importantly, when you had the floor, you were reminded that if you were about to call anyone a name that was not penned on their birth certificate you were likely entering the "danger zone." In other words - "Play nice or go home." For the most part everyone played nice and decisions were made.

I sat in awe as each article came before the majority for a vote. We spoke up, boisterously in many cases, "Aye" or "Nay". If the audible vote was a close call, Madam Forman asked for a show of hands and each hand was counted. The most fascinating part for me was the way the crowd interacted with each other... determined and passionate, yet respectful. I was seated next to a neighbor who I like and admire a lot. He and I began to note that we weren't voting in agreement on many issues. At one point, he patted my arm with a grin and said, "It's ok, I'll still love you even when you're wrong." After three of the votes I had just cast were defeated, a stranger seated behind me stuck a bag over my shoulder and offered me a Famous Amos cookie. She was "playing nice."

I have respect for our local, state and national elected officials. But I must say, after Nantucket's recent meeting, I am a big fan of this Town Meeting style of governing. It truly is democracy at its finest. Local residents presented informed and passionate reasons for their viewpoints. I gleaned understanding of the needs facing the community I live in. Mostly, I gained respect for friends, neighbors and fellow citizens who were willing to show up, speak up and cast their vote. Well done Nantucket, well done.

Cookie anyone?

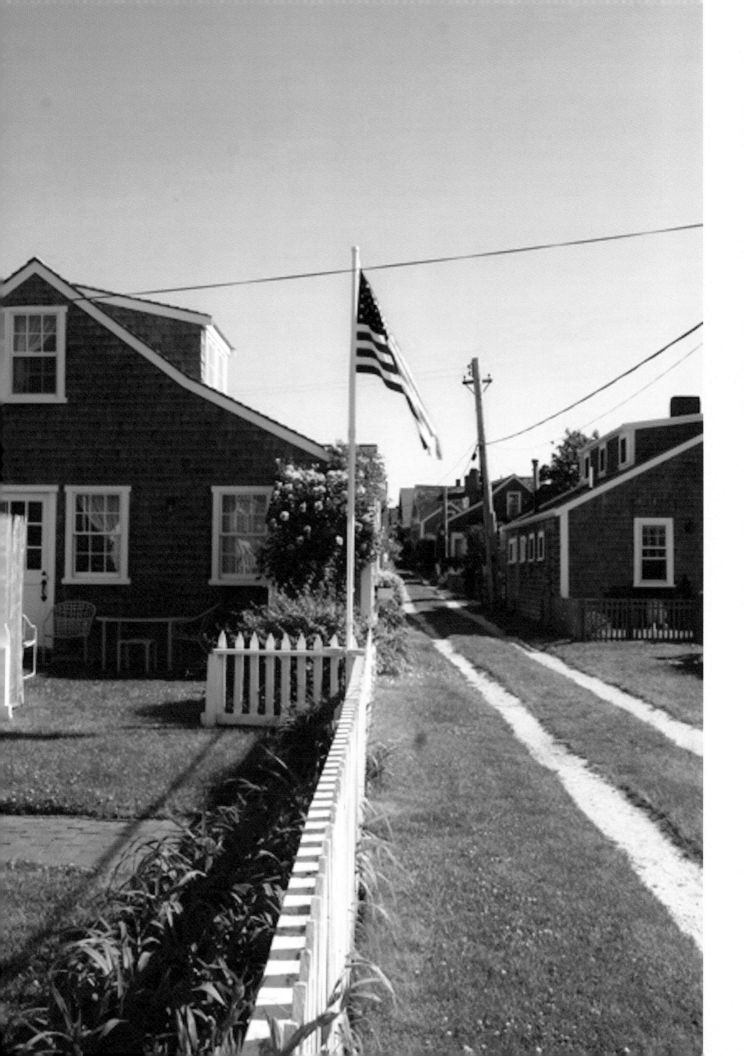

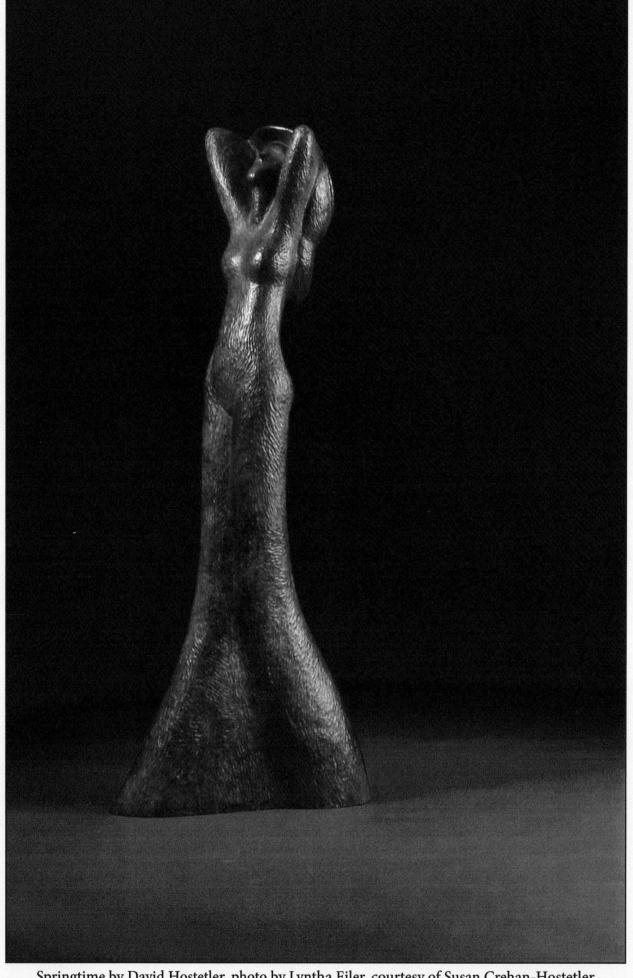

Springtime by David Hostetler, photo by Lyntha Eiler, courtesy of Susan Crehan-Hostetler

Springtime

Oh what a glorious time of year! The daffodils have all wiggled through the hard winter earth and popped open with a giant "hello world!" The birds have returned and are busy reconnecting with their spring and summer friends, moms and dads are pushing their smiling kiddos in carriages or wagons and best of all the windows are thrown open to usher in the spring air. There is simply nothing finer than inhaling a giant gulp of fresh spring oxygen. Ahhhh.

Nantucket awakens from its long winters nap in late March. Friends, neighbors and local business owners fill window boxes and planters with a wide variety of pansies, daffodils, hyacinth, violas and other fragrant wonders. It's as though everyone is preparing for a giant summer production. The curtain goes up the last weekend of April, when we kick the season off with a weekend long party – The Daffodil Festival.

I'm not sure what it is about this delightful season that puts a "spring" in our step and a smile on our face… but it certainly does. On my walk recently I noted that every single car I met had a smiling driver behind the wheel. Perhaps it's because in the spring everything is new. New plants and flowers, new buds on the trees, new coats of paint to freshen our homes, new babies, new romance, new attitudes, new opportunities and a new outlook. Spring, more than any other season, reminds us that everything has a beginning…and an end. It's time to bid our quiet season farewell and look ahead with childlike anticipation to sailboats bobbing in the harbor, Main Street bustling with activity and the arrival of our summer guests and friends.

There's a fabulous bronze sculpture, by renowned Nantucket artist and sculptor David Hostetler, that embodies all that is good about this season. The sculpture is aptly named "Springtime." Her head is tilted back to experience the warmth of the sunshine on her face, she's pulled her summer floppy hat off the shelf, dusted it off and has it tilted "just so" on her head. She's running her hands through her hair as she welcomes the day…and my favorite part of the piece is that she's stepping forward with her right foot as if to say to the world, "Yesterday is in the rearview mirror and I am confidently moving forward." That is Springtime. Yesterday is over; today is a new day.

Come experience the "official" Nantucket unveiling of Spring during the famed Daffodil Festival. Many of the restaurants and retail stores premiere new menus and merchandise. The island is painted in a spray of yellow as daffodils line the roadways and spill out of the window boxes. Grab your yellow floppy hat or suspenders and come celebrate Spring!

It's a new day.…

APRIL

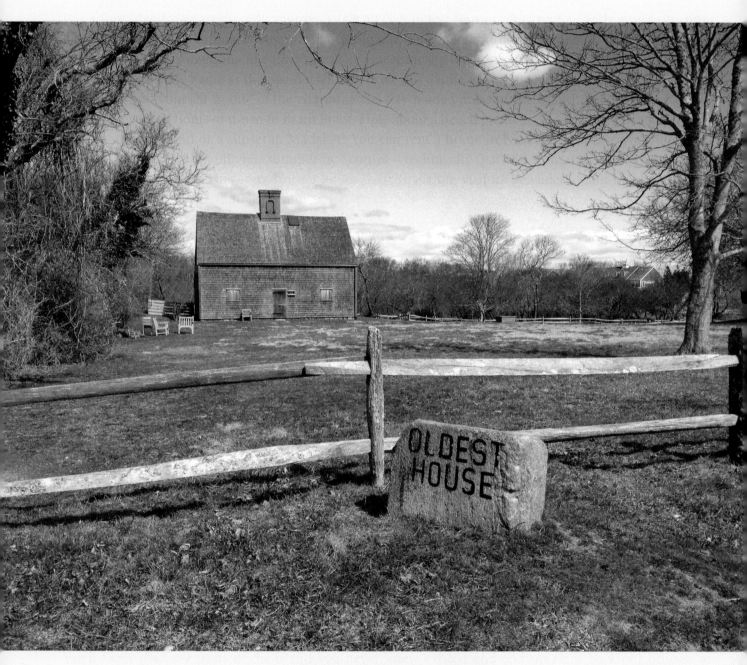

Jethro Coffin House, circa 1686

Timeless

Cliché: An *oldie, but* a *goodie*. Definition: 1.Something from the past that makes you feel good.

I have a confession to make. I'm one of those spoiled baby boomers who LOVES new stuff. A new sweater or a new pair of shoes makes me a happy girl. When it comes to real estate, just reading about all the amenities in the newer homes makes my heart go pitter-patter. The granite and stainless steel, the plasma televisions and Bose sound systems...oh my. Throw in some Italian Marble and it's all over - I'm giddy!

So, my first few months in the real estate world on this historic little island were eye opening to say the least. I've had a home here for over twenty years, so of course I was fully aware of the heritage and history that make the island so unique. But, until now, I've never fully appreciated the charm of the "antique" world or the idea of owning or renting an older home. I'm getting over myself quickly.

When I enter these antique homes on my rental visits I find myself having an emotional response. Whether it's a home built in the 1700's or one built in the 1930's, my reaction is the same - I want to know the story. Who are the people who lived here, loved here, struggled here, celebrated here...maybe suffered here? How many generations have filled the rooms with life and laughter? Some of the furnishings are equally intriguing: what letters or documents were penned at the quaint antique desk? How many babies were sung to sleep in the little rocker near the fireplace? I'm mesmerized by the parlors and gathering rooms and hidden back stairways.

The best lesson I'm learning about these historic properties is you can outfit them with enough modern conveniences to appease us 21st century humans. Many of the homes have been thoughtfully and tastefully restored to their original elegance. Most come complete with wireless internet, lovely linens and a fresh updated kitchen with all the amenities to make cooking fun and easy. But none of these modern additions eclipses their fabulous historic personalities.

It occurred to me recently what an amazing experience it would be for an extended family to rent one of these antique homes and treat their children or grandchildren to an authentic historical experience. You could go "all out" and make it an electronics free trip; spend the week with books and board games, outdoor nature walks and kick the can. No cell phones or computers - imagine! Meals could be eaten by candlelight and summer evenings spent gathered on the lawn or porch exchanging family stories. Or, you could simply meld the history of the home with our present day gadgets and gizmos and have great conversations about how people survived without modern day luxuries.

Nantucket is teaching me that new is good and old is good and when you combine all of the styles and designs, history and creativity that goes into each home, the island becomes a tapestry that shines as a masterful work of art. Thank you Nantucket for broadening my horizons and teaching me to embrace the...

"oldies but goodies."

GPS

For a tiny island measuring only approximately 14 X 3 miles, Nantucket is replete with numerous little destination spots. It's difficult to explain our geography and "neighborhood" system to new visitors. The conversation goes something like this: Yes, there is technically only one "town" and yes, that's correct the town bears the same name as the island itself. But drive just a mile or two in any direction from downtown and you'll find yourself in one of the charming cleverly named areas of the island. You can drive out to Quidnet, over to Dionis or down to Brant Point. How about a beach picnic in Madequecham, a kayak ride on Sessachacha Pond or a sunset in Madaket? You can rent a home in Nashaquessit, take your dog for a walk in Tuppancy or spend your summer in 'Sconset – technically that's Siasconset, but we affectionately call it "Sconset." Huh? This conversation leaves most first time visitors bewildered and befuddled…but generally intrigued enough to learn more.

The confusion mounts when guests arrive and have to navigate the island for the very first time. If you were born and raised here, the concept of being "lost" or confused on Nantucket is likely foreign to you. But most of us remember well our first visit to the island. Initially it can be a bit disorienting. Most of the houses are grey and look very similar. Every street is quaint and narrow and leads to…well, more quaint and narrow streets that eventually dead-end at one of the many beautiful beaches (it is an island after all).

The complex island area system is compounded by the unusual and sometimes hard to pronounce names. A few weeks ago, a colleague and I went on an island wide tour to research potential sales listings. I had the audible GPS system turned on in my car and as Helen (my British accented navigation friend) directed us, my colleague and I burst out laughing. "Turn right on Madaket (Muh-daaaa-cat) Road" she instructed. Later she advised us to bear right onto Wauwinet (Wow-why-net) Road. No wonder, we concluded, are visitors initially a bit overwhelmed. Even poor Helen is confused.

There is good news. Within a day or two of their arrival, visitors are quickly acclimated and it soon becomes a right of passage to learn the correct pronunciation of the many island areas. They also quickly learn that it's virtually impossible to become "lost" on Nantucket. Taking a wrong turn down a narrow sand road is actually how one rapidly becomes acquainted with the island. Secret paths and shortcuts are discovered, along with beautiful hidden walking paths, secluded beaches and scenic conservation areas.

So don't be apprehensive if you're planning your first visit to Nantucket or if you've been visiting or lived here for awhile and find yourself taking a wrong turn. Follow the road less traveled and see where it leads. You'll likely discover parts of the island you never knew existed and end up right back out on one of the main roads whose name you'll soon be proudly dropping at dinner parties (pronounced correctly of course!) Should your pre-programmed GPS system lead you astray or botch the pronunciation of one of Nantucket's streets or neighborhoods, give her a break – it's happened to the best of us!

Recalibrate.

WHERE THE HECK IS EASY STREET?

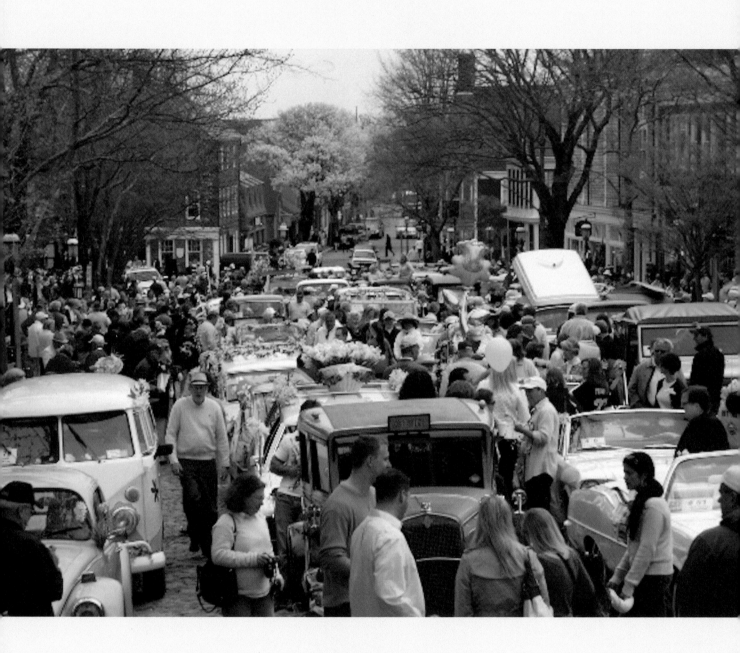

Daffy Daze

No chance of seeing red the last weekend in April on our little island. It's all yellow, all the time. Yellow flowers, yellow purses, yellow cars, bikes, hats, hair (yes, you read that right) and even a couple of yellow dogs (bottle dye, not salon no doubt). The streets, flowerbeds, window boxes and centerpieces are all adorned with daffodils. It's speculated that over three million daffys pop open on the island every year. I haven't stopped to count them all, but trust me, they are everywhere!

Nobody throws a party like the people of Nantucket and Daffodil Weekend does not disappoint. Hundreds (perhaps thousands?) of residents, guests, friends and family gather on the island sporting their yellow clothing, accessories, baskets and bows to toast the guest of honor...the daffodil! There is electricity in the air on Saturday morning as the crowd congregates downtown to catch a first glimpse of the decorated classic cars, the bedazzled bicycles and the extravagant hats and bonnets (those Royal Wedding guests have nothing on Nantucket!)

From my second floor office window on parade day, as far as you can see down Main Street, our little town is a sea of yellow. Everywhere you look people are laughing and smiling, admiring their neighbor's outrageous costumes or extravagant decorations. There are colonial girls donning elaborate yellow dresses and large curly wigs. There is a VW Bug dressed up like a rooster - complete with a giant red tongue peeking out from under the hood and a tape recorded "cock a doodle doo" blaring from its under-carriage. Down the street sits a yellow truck full of toothless vagabonds who proudly dub themselves the Nantucket Hillbillies. One brave soul wanders the streets in his green pants, green sweater and huge yellow daffodil bonnet, while smiling from ear to ear.

The party really gets started as the parade begins to head up Main Street led by a police escort, an antique firetruck and the Honorary Mayor perched atop a convertible. There is a flashback to the sixties as VW Mini Buses and Bugs splashed with yellow flowers and wreaths cruise up the street. The wreaths come in a wide variety of shapes; whales, smiley faces, hearts and even a peace sign. The message is clear - peace, love and daffodils! It's intriguing that a little yellow flower has the ability to generate so much creativity, fun and genuine "daffy" behavior, but it certainly does.

If you are unable to join the festivities on Daffodil Weekend don't worry, there are many opportunities for fun on Nantucket. Be sure to bring along your camera. You just never know what you might see.

Party on...

Becalmed

Merriam-Webster defines "becalmed" as being rendered motionless by lack of wind or "to stop progress." Of course, if you're a sailor you don't like finding yourself becalmed, but if you're a busy, overworked and somewhat exhausted average American you long for this sometimes elusive phenomenon. Most residents of and visitors to Nantucket agree that within moments of arriving on the island their heart-rate slows a little, their blood pressure stabilizes and they exhale. Personally, I prefer Merriam-Webster's additional definition of becalmed: to make calm - to soothe. That's what Nantucket is famous for - it's soothing effect on our psyche.

The photo opposite was taken on one of the many calm days we experience during winter and spring. The island in general is always calming, but there's something about rounding Brant Point when the waters are smooth as glass that deepens her peaceful effect. Who among us doesn't appreciate a smooth ride in life? Instinctively, the first place my eyes are drawn to when I enter the ferry ticket office is that little sign behind the counter announcing the sea conditions. I always love to see those four magic letters: C-A-L-M. When left with no options, I can endure the rough seas, but I much prefer to travel bump free thank you very much.

First time visitors to the island are often surprised by her quieting influence. Our number one request for rental home amenities is wireless internet service. Tenants arrive convinced they will need to stay "plugged in" to the outside world while on vacation. To an extent, the modern world we live in demands it. But over and over again two to three days into their stay tenants confess they have "turned off" their electronic devises and are choosing to enjoy their morning coffee or evening cocktail with no distractions beyond Nantucket's singing birds, beautiful ocean breezes or her famed sunsets.

I've heard countless stories from guests, friends and neighbors about how time on Nantucket transformed their business and family lives, their physical health and their overall perspective. They arrive reeling from the busyness of their everyday worlds and within days (sometimes only hours) they discover tranquility that is hard to describe or define. Once situated on their beach blanket, nestled into a rocker on the front porch of their rental home or dozing in a hammock under a tree on their own back lawn, Nantucket residents and guests often find themselves "rendered motionless" - ahhh, becalmed indeed.

Are you dreaming of some slower paced days? In need of a little calm in your life? Perhaps even wishing you could find yourself "rendered motionless" for a week or two...maybe even the entire summer? If so, come spend some time on Nantucket. Choose an oceanfront rental or a quiet little cottage in the historic district. Make plans to visit one of Nantucket's beautiful beaches, take a long quiet hike in Sanford Farm or simply find the nearest hammock and do nothing at all.

Calm down.

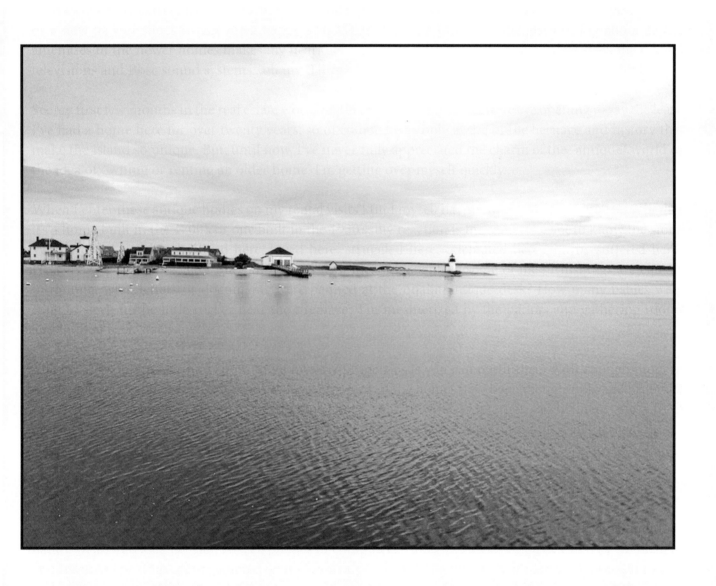

MAY

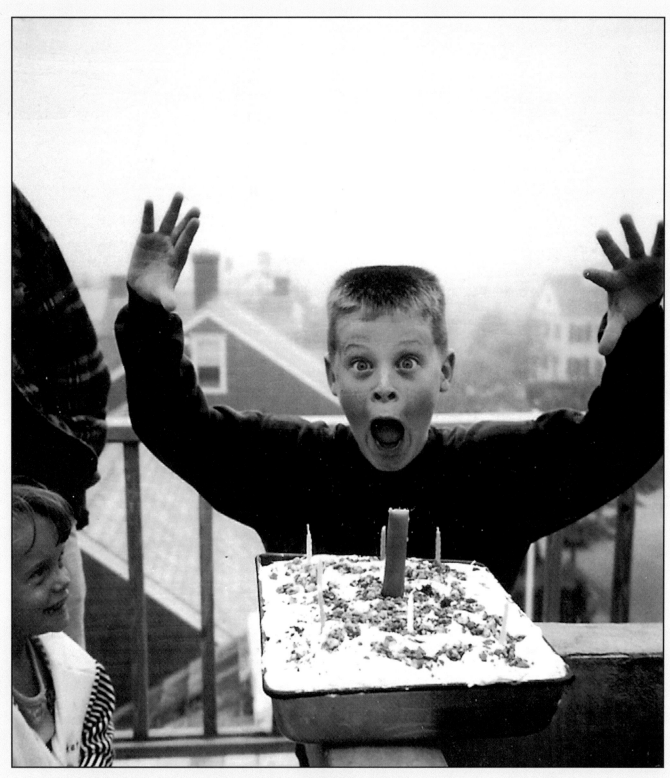

Drew Dunlap, 8th birthday

What's So Funny?

I bet there isn't a mom or dad alive who can't relate to the photo opposite. Every family has a "class clown." Somehow I managed to get four of them…the one in the photo being King Clown (my son, Mr. Funny Guy). When the kids were little I spent a lot of hours and energy trying to squelch the clown. I wanted just one family photo where we all looked…well…normal.

Now that the kids are grown and I have 20/20 hindsight, I wish I'd spent more time and energy fostering those clowns – providing them outlets and opportunities to bring the house down with their funny antics and comedy routines. All my kids are innately wired to be funny…it's in their DNA. Now, years later, these silly photos are some of my favorites. Perhaps the most delightful element in the photo is his little sister staring up at him with absolute adoration on her face. My daughter always wanted to grow up and be even half as funny as her big brothers. She's getting close. She's pursuing an acting career and doing open-mic improv whenever she gets the chance. Being funny and making people laugh is her passion and if she has her way will someday be her career. What a great job – making people laugh.

Laughter truly is good for our physical bodies and refreshment for our souls. It lightens our load, makes us happy and reminds us not to take the stresses of life too serious. We have friends who wrote a marriage book and listed laughter as one of the most important elements of a successful relationship…even devising an acronym for LAUGHS to remind couples to keep the fun alive. I think laughter is also a lifesaver in the workplace. My colleagues make me laugh every single day; sometimes on purpose with a prank or funny story and sometimes unwittingly by something they say or do. Real Estate may be no laughing matter, but the determination to keep our attitudes light, even when circumstances are tense, creates a really fun work environment.

Milton Berle once said, "Laugher is an instant vacation." Never is that more true than on Nantucket. I have never attended a Nantucket dinner party, beach barbeque or social event that wasn't filled with laughter. People here genuinely know how to have fun and enjoy more than a few good laughs. Island organizations have formed to embrace and promote comedy in our lives. Nantucket Improv is on the stage at the Methodist Church every Sunday night at 8:30 p.m. from June to October and features local funny guys and gals. The Nantucket Comedy Festival is held in late July and offers three days of hilarious entertainment for young and old. Proceeds benefit ProjACK Comedy – the first stand-up comedy program and curriculum developed for high schools, currently being utilized at NHS and the New School.

As you organize your Nantucket summer agenda, plan to take advantage of the wide variety of opportunities to laugh until your sides split. Attend one of the comedy events, enjoy a funny theater presentation or simply invite a few class clowns to dinner and let the laughter commence.

LOL

Just Bluffin'

Those who have never been to Nantucket might find it hard to envision the wide variety of elevations and topography that exist on a little body of sand. From rocky jetties, to a pebble covered shoreline on some parts of the island, to endless stretches of silky sand and rolling dunes on another. No matter where your bare feet land, you are guaranteed to find yourself exposed to sheer beauty. Each area of Nantucket is unique and dramatic in its own right.

Depending on the day, one of my favorite things to do is choose a part of the island known for its high bluffs and take a long walk. There is something quite daring about walking right along the edge of the place where you live. The vantage point from high places on the island is breathtaking. Expansive views of the Atlantic Ocean as far as the eye can see from some bluffs. From others, ocean views and harbor and town scenes are on display.

One of my favorite bluff walks is the one in 'Sconset, where you wind along a little secret path that cuts directly in front of some of the extraordinary Baxter Road homes. In the late spring and summer the bluffs face is a stunning display of aromatic splendor as the rosa rugosa and dune grass adorn the rugged surface. On a clear day, you can watch the rip current "perform" on the horizon as it sprays huge bursts of water dozens of feet into the air. If you're really lucky you might see some seal heads bobbing in the water or a whale spouting in the distance.

These walks and the vantage point they provide always remind me that life is all about perspective. For fun, I sometimes walk down one of the steep sets of beach stairs to the sand. I walk along the shore and look up at the underside of the bluff. From below, it looks rugged and harsh, impossible to climb -overwhelming even. But once I'm back up those steps, feet firmly planted on the high bluff looking out at the horizon, gazing at the magical Nantucket scenery…the world looks brighter.

Sometimes all you have to do is get to "higher ground" for your outlook to change. There are dozens of quotes that embody this concept: "Soar to new heights," "Rise above it," "Stay on top of it." I'm sure you know many more. I might be biased, but I believe Nantucket is one of the best places in the world to gain a fresh perspective. Walking along one of the many island bluffs, gazing out at the Atlantic Ocean while inhaling the fresh air, the universe seems to whisper, "All is right with the world."

The next time you're in the mood for a great walk, be sure to make your way to one of the bluffs. Spend some time strolling along the edge or just gazing out at the vista. Embrace the beauty, marvel at the expansiveness and reflect on how good life looks from higher ground.

It's all about perspective.

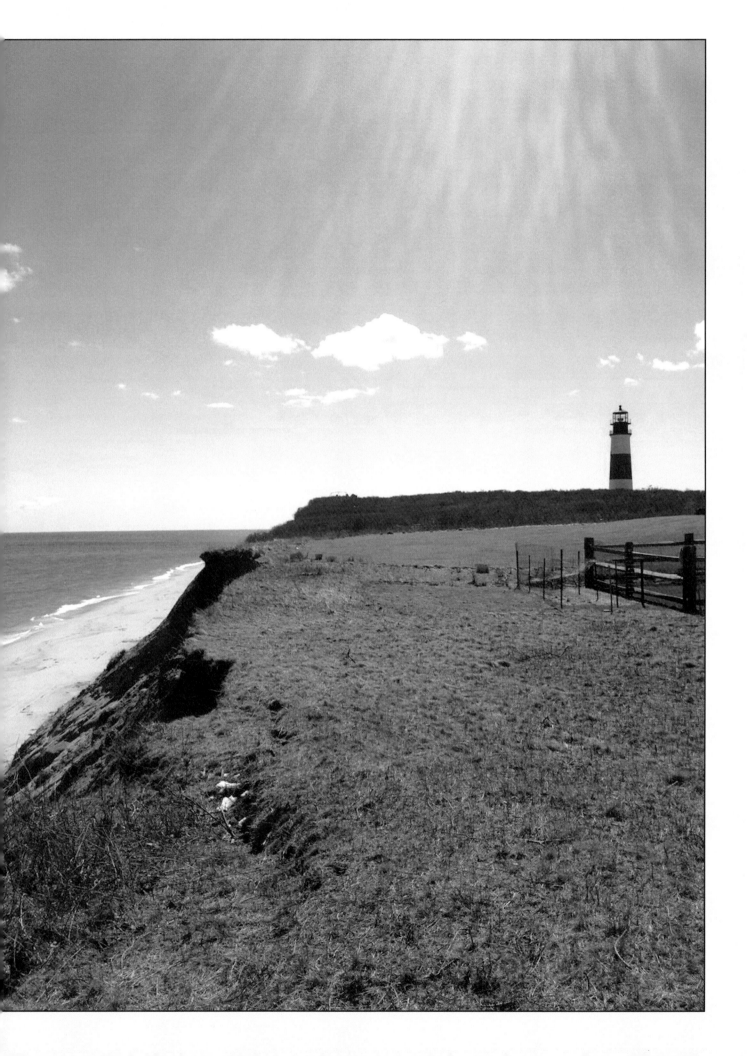

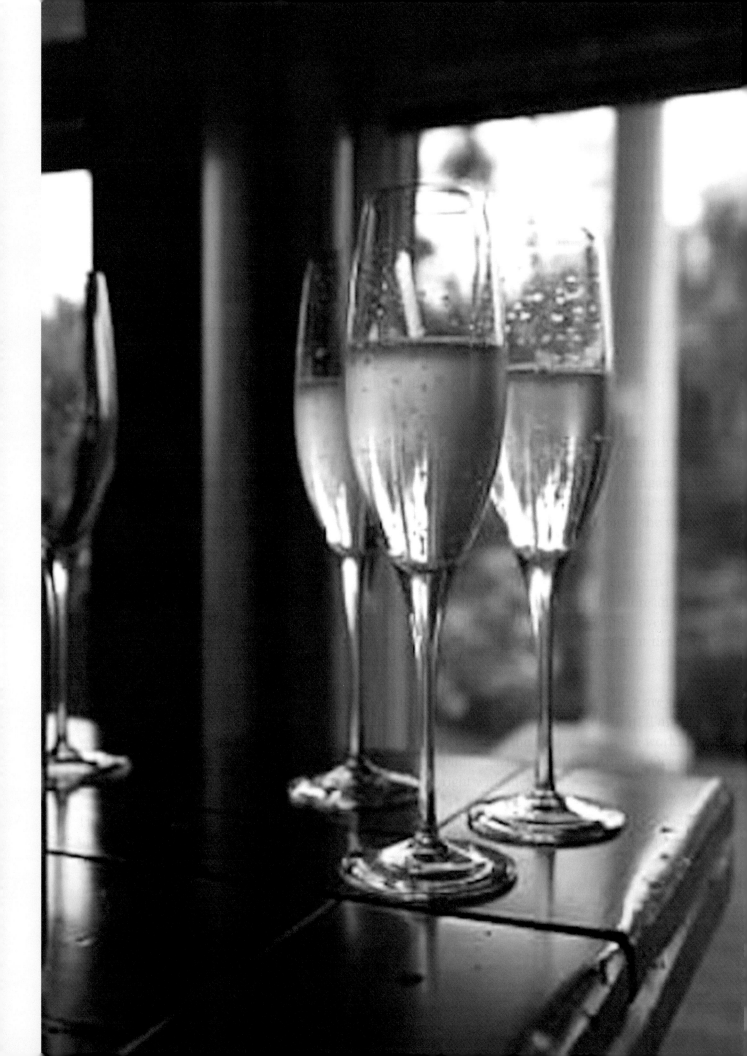

Toast to Nantucket

The third weekend in May the island is a flurry of raised glasses and food parings as we celebrate the annual Nantucket Wine Festival. My husband and I were lucky enough to attend several of the special events that were part of the recent festivities. The festival showcased over one hundred sixty wineries, a wide variety of delectable menu items and grapes of every size and color.

My husband Dan loves everything about wine. He likes to swirl it and marvel at the legs as they cling to the side of the glass. He likes to put his nose in the glass, inhale the aroma and admire the artistry on the labels. Of course, ultimately, he enjoys sipping it. I like wine too, but I must confess I don't really understand all the pomp and circumstance. If it tastes good I drink it, if it doesn't…I pass it on to Dan to swirl, sniff and sip.

We had a great time at the opening night gala. Many of the wines were on display and available to sample. One of the best parts of the event was talking with the wine makers. Their passion for their work was evident as they described the process of growing, bottling and all the details in between. There's something very special about the opportunity to personally create and market something so many people will enjoy. It's easy to see why many of them consider it an art.

Perhaps the most meaningful part of any wine experience (or any beverage for that matter) is the opportunity we all take to raise our glass before we drink. There were many toasts during the festival – to friends and family, to good health and good times, to peace and prosperity. As we kicked off a new summer season, we declared it a good time to raise a glass to our beloved Nantucket.

Here's to you Nantucket: To your beautiful landscape and storybook harbor. To your breathtaking sunrises and show-stopping sunsets. To your rich history, quaint cobblestones, manicured gardens, adorned window boxes, first-rate restaurants, world class Inns, hotels and rental homes. To your rolling dunes, mesmerizing ocean views, world famous beaches and gracious hospitable residents. To all of the things that make you unique, to all of the memories we've shared and for the many ways you've made us better – we thank you. To you our beloved Nantucket.

Clink Clink.

Come Sail Away

There is nothing like a few hundred colorful sails dancing across the sun kissed Atlantic Ocean to put you in the mood for summer. The calendar doesn't have to say June for summer to officially get underway on Nantucket. The last weekend in May marks the beginning of the summertime season with the Annual FIGAWI Race. The great thing about this race is it doesn't discriminate. Big boats, small boats, fast boats, slow boats, sailboats and power boats - all are welcome! The serious racers engage their competitive spirits while other boating enthusiasts welcome the opportunity to be out on the open water. The race always draws a huge crowd of exuberant spectators.

Several years ago I sat on a blanket near the Brant Point Lighthouse with my two youngest kids and watched as the first sailboats entered the channel. Excited onlookers whooped and hollered, applauded and waved as the winning boat sailed by. We watched expectantly for "our team" to arrive (my husband and two of his buddies on our 26 foot cutter-rigged sloop). This was his first (and last I might add) FIGAWI race and we were certain he would arrive with some of the early racers. He had actually called us from his cell phone at 10:00 a.m. to announce he was in FIRST place! We were so proud. He didn't finish first, but did arrive with the first dozen or so boats and all aboard were proudly waving and smiling as they rounded Brant Point. I should have realized something was amiss when the other early boats were all sleek, new racing boats. We loved our Destinie, but she wasn't ever sleek and was beginning to show her age at almost twenty years old. Turns out there was an OFFICIAL starting time for the race (imagine that!) Captain Dan and his crew were apparently oblivious to this fact and pulled up anchor and set sail from Hyannis at sun-up...so by 10:00 a.m. he really was in first place. No harm done - the official winner and runners-up received their trophies (Captain Dan got a high five from his kids for giving it the old college try) and a good time was had by all.

That's the great thing about Nantucket - whether you are a novice boat owner or a seasoned sailor - there are a number of ways you can enjoy the water. If you miss FIGAWI, you can join the fun in August for the official "Race Week" or the Nantucket Opera House Cup. If you love being on the water, but are not completely comfortable at the helm - you can take classes at the Nantucket Community Sailing School. In their younger days, my children spent three summers learning all the ins and outs of sailing with NCS. The instructors even taught them how to right a capsized daysailer and they got pretty good at it. The experience boosted their confidence in boat handling and helped foster an already innate love for the water. And the classes aren't just for kids. Several of my girlfriends joined together and took some lessons one summer. It was great social time and they all reported gaining real enthusiasm for the sport.

Whether you love to captain or crew a boat yourself or simply enjoy sitting on a blanket on the seashore watching the boats glide by, join the thousands of Nantucket residents and visitors alike who embrace many summer boating opportunities and possibly even sail off into the sunset.

Welcome aboard!

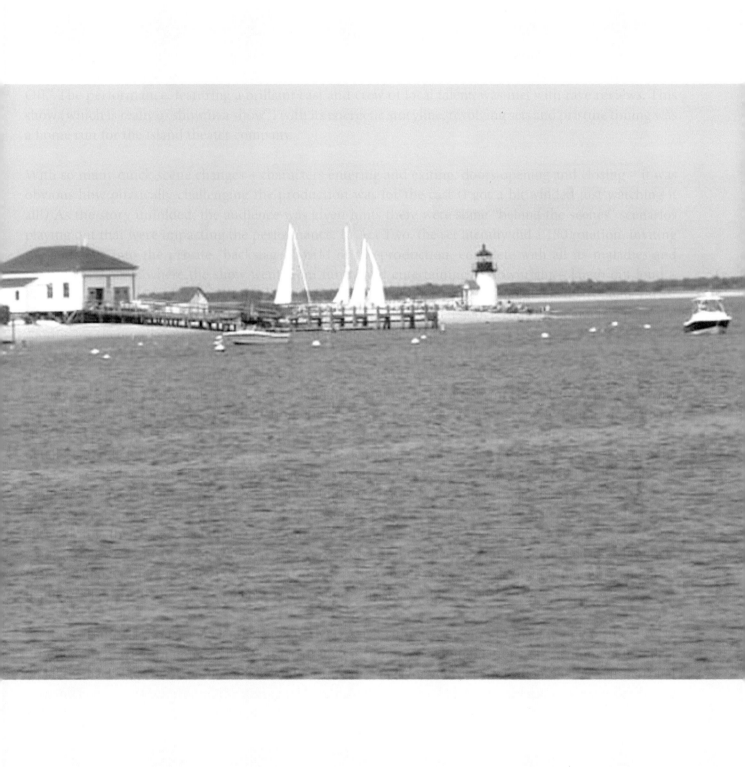

JUNE

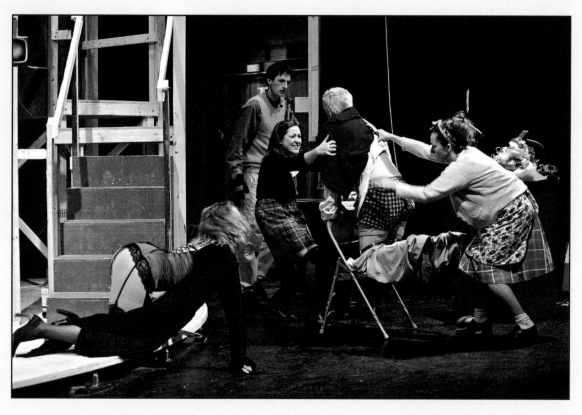

Photo courtesy of Theatre Workshop of Nantucket, photographer Pixel Perfect.

Backstage

I love spending a summer evening in the audience of any production put on by the Theatre Workshop of Nantucket, but I have to say, one of my all time favorites was their rendition of the British Farce, "Noises Off." The performance, featuring a brilliant cast and crew of local talent, was met with rave reviews. This show (which is really a "show in a show") with its energetic storyline, revolving sets and pristine timing was a home run for the island theater company.

With so many quick scene changes – characters entering and exiting, doors opening and closing – it was obvious how physically challenging the production was for the cast (I got a bit winded just watching it all!) As the story unfolded, the audience was given hints there were some "behind the scenes" scenarios playing out that were impacting the performance. In Act Two, the set literally did a 180 rotation, inviting the audience into the private "backstage" world of the production, complete with all its maladies and challenges. This is where the show went from funny and entertaining to downright – laugh out loud – hilarious. As the comedy of errors played out backstage and the characters took their turns being thrust through the revolving doors so the "show could go on," I found myself both feeling the characters pain and rooting for their success as they attempted to hold it together.

The show – "Noises Off" – as much as it's a farce and an entertaining comedic stage show, is also actually a parody of real life…especially on a tourist island like Nantucket. In late spring, the island is busy working fervently to prepare its summer "production" for island guests. Restaurant owners perfect their menu items, shop keepers put the final touches on their window displays and homeowners scramble to make sure every detail is attended to so their summer tenants will be delighted upon arrival. I'm always in awe watching the "backstage" flurry of activity as summer manifests itself…and I remain in awe each time I arrive early at a rental home for a tenant check-in. As I look around the homes, I'm reminded that none of the preparation happens by accident. The cleaning crews, landscapers, property managers, real estate agents and owners all work together like a synchronized swim team to ensure that each home is turned over and "tenant ready" each week. Just like in "Noises Off" every now and then there are unexpected backstage blunders that threaten to interrupt the audience enjoyment. A few phone calls, some flexibility, ingenuity and great teamwork and virtually every challenge is overcome. The show, indeed, must go on.

As the curtain rises on your Nantucket experience each summer, be sure to include one of the TWN's productions in your itinerary. When you arrive at your summer accommodations, take a moment to reflect on all the backstage preparations involved in setting the stage for your ideal vacation. Invite your personal cast and crew to gather around the dining table, utilize the props at hand (a board game, some videos or an old fashioned game of cards) and enjoy the show.

Break a leg!

Down on Main Street

The beloved singer, Bob Seger, has a memory of his Main Street – "standing on the corner at midnight, trying to get my courage up." We all have a memory of Main Street somewhere don't we? Maybe it's our hometown, where grandma lives, or just some quaint little community we passed through on our way to somewhere else. Virtually every town has a Main Street where the action happens and memories are made.

I was born and raised in a small town in Iowa (population less than 1400!), so I have a lifetime of Main Street memories. As a kid, we walked to Main Street for milkshakes at the local soda fountain, penny candy at the Dime Store and skating at the local roller rink. One week every summer they would completely close down Main Street when the carnival came to town. The street was jam packed with exhilarating rides, booths boasting games and prizes and the smell of cotton candy and funnel cakes wafted across the entire town. As a teen, you weren't cool until you turned sixteen, got the keys to dad's Pontiac and "cruised Main" with eight friends piled into the car. We would burn through an entire tank of gas in one night and never leave a six square block area. Main Street memories.

On Nantucket, Main Street is the center of the universe. The charming cobblestone streets begin at the harbor and wind all the way to "Upper Main." Most of the major island events take place in the two block Main Street area – 4th of July water fight, Christmas Eve drawing, Halloween parade and many more. From my window on the second floor of our Main Street office, I love watching what takes place on Main Street Nantucket on any average afternoon – couples strolling hand in hand, kids licking ice cream cones, dogs tied to a post napping while mom shops and friends and neighbors gathered on one of the many benches along the street chatting about their lives. Main Street anywhere, but certainly on Nantucket, makes us feel at home.

The next time you're looking for something to do on Nantucket, make your way to Main Street. Meander in and out of the shops, linger in one of the art galleries, stop by the pharmacy for an ice cream or bring along a friend and pull up a bench for some good old-fashioned conversation. And then, as Bob Segar says, "drift back in time and find your feet"….

Down on Main Street

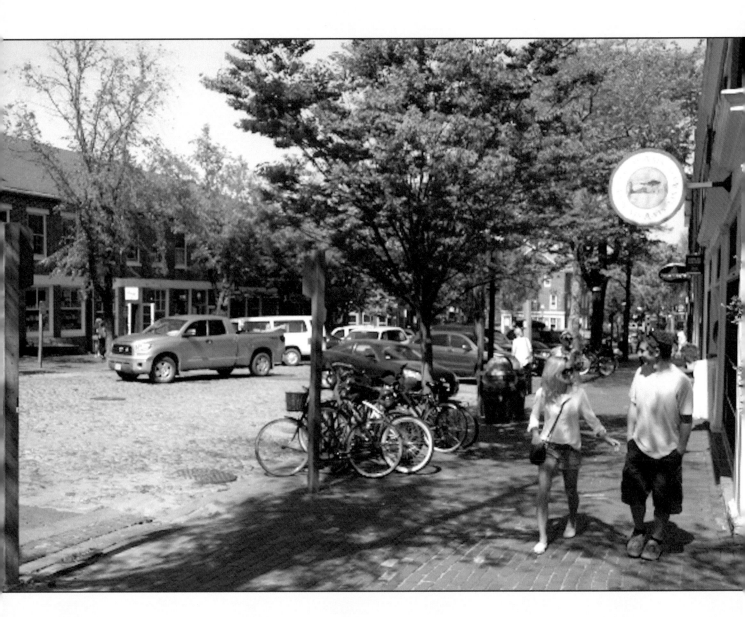

Food Network

Nantucket Island is well known for serving up some of the finest food imaginable. There are more 4-5 star restaurants per square mile than virtually anywhere else in the world. Talented chefs and their staff work tirelessly to "wow" diners with creative and delicious new menu items each season. In early June, many of the restaurants "show off" a few of their new menu sensations during Nantucket Restaurant Week. I can't take advantage of all of them, but one recent evening I found some time to slip into a quiet corner table at Oran Mor with old friends. We sampled smoked salmon, perfectly seared fluke and a braised duck dish that left me wanting to lick the plate. The evening was festive, the food divine…a great start to summer.

Just a couple nights later, food was once again the impetus to a gathering of friends, neighbors and island visitors as we came together at the Nantucket Yacht Club for the Annual Chef's Dinner to benefit the Nantucket Food Pantry. The always-popular event featured four courses of delectable cuisine from several of the islands top chefs. 100% of the proceeds were donated to support the Nantucket Food Pantry.

On an island well known for its affluence, it's hard to imagine many are struggling to put food on their tables. Yet, the Food Pantry Director, Andy Reis, announced that activity was up over 6% from the previous year and the Pantry now services over 10% of the year round island population. As we dined on the extraordinary cuisine, I found myself wrestling with the irony. The table centerpieces told the story of why the evening's event was so important. Pantry staples like whole-wheat pasta and rice are weekly necessities for many of our island friends and neighbors. There is some good news. One of the board members informed us that very few of the Pantry participants stay in the program for long. Most find themselves in a temporary position of need and once back on their feet become loyal donors and volunteers of the Pantry. A true "pay it forward" organization.

It's heartwarming to watch the island unite for a number of good causes. It's particularly great to watch some of the island chefs donate their time, talents…and food itself…to benefit the Nantucket Food Pantry. Many other organizations are rallying around this cause as well. NAREB (Nantucket Association of Real Estate Brokers) has joined with Pantry Partners to assist in collecting unused food items from the rental homes. Some even leave food collection bags in the rental homes and personally pick the items up after check out to make the process easier for tenants to donate.

Ronald Reagan once said, "All great change in America begins at the dinner table." As you gather family and network of friends around your Nantucket table in the summer, brainstorm ways you too can support the efforts of the Nantucket Food Pantry. Deliver unused food items to one of the designated drop off spots, organize a Food Pantry specific shopping trip or simply send a monetary gift.

Make a difference.

Lights Camera ACKtion

In mid to late June, Nantucket looks a bit like a Hollywood movie set. Snuggled onto a Main Street bench, it's fun to watch all of the badge bearing visitors wander into the shops, stroll up the sidewalks and chat curbside with friends as they experience the charm of the magical island location of the Annual Nantucket Film Festival. Our streets, shops and restaurants are filled to the brim with actors, directors, writers and producers.

The red carpet gets rolled out at a series of entertaining events all across the island as the festival offers a little something for everyone. Dozens of movies are shown in various locations over a five-day period. Guests and island residents are invited to opening and closing night parties, coffee with some of the writers, directors and actors and several "headline" events, which include a late night storytelling session where Jerry Stiller, Anne Meara and Brian Williams have been known to steal the show. Perhaps the most talked about event (and the first to sell out!) is the comedy round table on Sunday afternoon where celebrities like Ben Stiller, Seth Meyer and Jerry Seinfeld have brought down the house.

It's ironic that Hollywood and the film industry have found a home on Nantucket. For years, our friends and family who visit here for the first time always comment that it looks like something out of a movie. In fact, Nantucket has been the setting or the basis for several Hollywood movies. Many best-selling books (fiction and non-fiction!) showcase the island, its history, its residents and visitors. The island offers the perfect ingredients for Hollywood's recipe for success: the backdrop of a quaint New England seaside community, a menagerie of eclectic personalities, a cup of history, a tablespoon of beach sand, a dash of romance and a sprinkle of local drama.

One of my favorite things about the film festival weekend is watching all the starry eyed young people in pursuit of their artistic dreams and careers. One of the recent winners of the screenwriting award was a young "kid," Ben Queen, who is just slightly older than one of my sons. He's one of Pixars new rising stars as the writer of the animated movie Cars 2. It is impressive to see how these gifted young artists – writers, actors and directors – have found their niche in the world of entertainment. It's perhaps even more impressive that our little island is providing a venue where the achievements of young and old alike can be recognized.

Whether you're a film critic, a star-gazer or simply enjoy a good flick, this is a Nantucket affair not to be missed. Begin planning ahead and be sure to mark your calendars for this annual June event. Set the stage in one of Nantucket's beautiful homes, bring your personal cast of characters (friends and family!) and come create your own Nantucket storyline.

That's a wrap!

Photo courtesy of Nantucket Film Festival

JULY

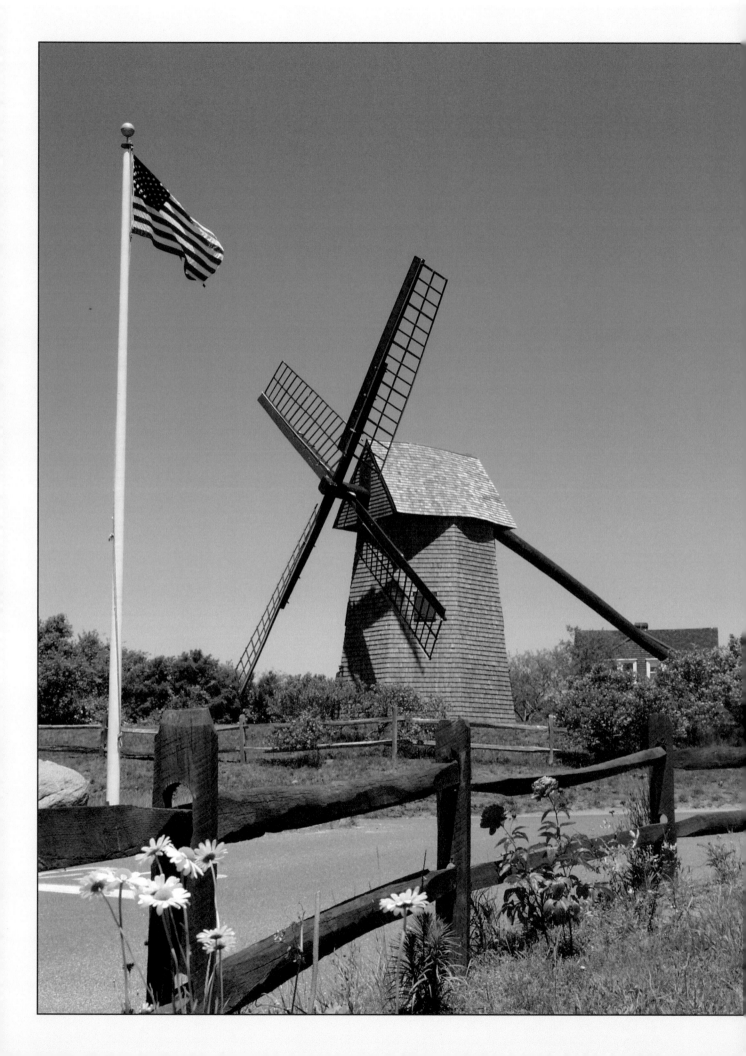

God Bless The USA

The celebration is electrifying on Main Street on Independence Day as thousands of exuberant, red white and blue clad locals and visitors cram the streets of downtown Nantucket. Eager contestants gobble blueberry pies and watermelon slices in pursuit of the coveted blue ribbons. Bicycles and puppies are adorned with patriotic streamers and bows. Tiny tots and grandparents alike, vie for the goofy holiday hat award. On Nantucket, the party isn't finished until the fire trucks have unleashed a torrent of water up and down Main Street during the annual 4th of July water fight. Of course, the big finale of the holiday, all across America, is the moment when red, white and blue explosions erupt overhead and we all oooh, ahhh and sigh. At the party we attend, someone always breaks into song and leads us in America The Beautiful. We all applaud...and then get very quiet while the big fireworks finale illuminates the night sky and we consider the land we love - "from sea to shining sea."

There are hundreds of beautiful songs about our amazing country, but I think Lee Greenwood captured the heartbeat of every American when he wrote *"God Bless the USA."* As I sit down to write and paint a Nantucket "word picture" that will capture the enthusiastic way Nantucket celebrates Independence Day, I realize that our holiday festivities are also the nations festivities. It's the one time each year when all Nantucketers, and all Americans for that matter, find common ground. Race, color, creed, religious background, political party, man, woman or child; on this one very special day we all place our collective hands across our hearts and pledge our allegiance not just to the flag, but to a country that has truly given each of us *"life, liberty and the pursuit of happiness."*

Nantucket provides the perfect backdrop for a celebration of this scope. The island is steeped in the history of our forefathers. Benjamin Franklin's mother was born on this island - imagine! One of my favorite events is listening to a few of the townspeople read the Declaration of Independence from a stage in the center of Main Street. As I soak up every word, I'm reminded of where we come from and how lucky we are to live in a place that honors the past while building the future.

If a Nantucket 4th of July celebration is always part of your summer agenda, then you likely begin planning for the next year even as you're still polishing off the leftover hot dogs and apple pie from the current year. What new recipes will you serve at the picnic? Where can you purchase one of those goofy tri-colored hats? How can you train to edge out that scrawny kid in the pie-eating contest? Most importantly, you get a jump-start on designing your guest list as you consider which friends and family will join you for this very special weekend. If you've never had the pleasure of celebrating the nation's independence on this nostalgic island, please begin making plans now to come to a place that will take you back in time and leave you singing along with Lee Greenwood.

"There ain't no doubt, I love this land...."

Le Fog

It's summertime and "the livin is easy." Bright-eyed beachgoers, donned in board shorts and polka dot bikinis, load their coolers with sandwiches, salads, cold drinks and cookies. Off they go in their shiny Jeeps, ready for a balmy, sun-soaked beach day. Beach chairs go down, sunscreen goes on, frisbees get distributed and the fun begins. Who will be the first to take the dare and dive headfirst into the Atlantic Ocean on this perfect summer day? All is well with the world.

Suddenly Mother Nature flips a switch, a magic door is thrown open and an oversized waft of grey, wet, smoke-like matter descends upon the beach revelers and soon they can barely glimpse the waters edge. F-O-G. It happens on Nantucket. I am not a meteorologist so I certainly don't understand all the scientific, atmospheric explanations for why fog happens...but there is no question that on any given summer day in Nantucket it can appear when you least expect it.

Fog is an interesting phenomenon. Unlike other tricks Mother Nature has up her sleeve, fog - in and of itself - is not harmful. It can't blow you over or sweep you away. It doesn't damage the landscape or compromise the architecture. It just is. I'm always amazed at how easy it is to lose perspective when the fog rolls in. You can get disoriented, confused, sometimes even claustrophobic. I always like to stop and remind myself that just on the other side of that thick white blanket, nothing has changed - the world is exactly the way it was before - my human eyes just can't see it. I'm certain that's why we have phrases like "I'm in a fog" or "I'll be so relieved when the fog lifts."

In our family, we like to make up acronyms to remind us how to respond to a foggy day or a foggy life circumstance. Focus On Goodness or Follow Our Gut. I'm sure you can think of some clever quips of your own. The point is, don't let a foggy day get you down. Welcome the opportunity to be still. Try to remember all the details of the landscape (geographical or circumstantial) you took for granted just moments before the white stuff rolled in. If you find yourself far from home when the white cloud descends, by all means keep your ear out for the foghorn, use that compass on your cell phone...or just take a seat and wait for it to lift. It always does.

The next time you find yourself on Nantucket when the fog rolls in, grab a friend or loved one and take a stroll. Notice that you whisper when you talk (nobody uses their "outside voice" in the fog!). Breathe in the moist air and embrace the opportunity to live in the moment.

Fog Happens.

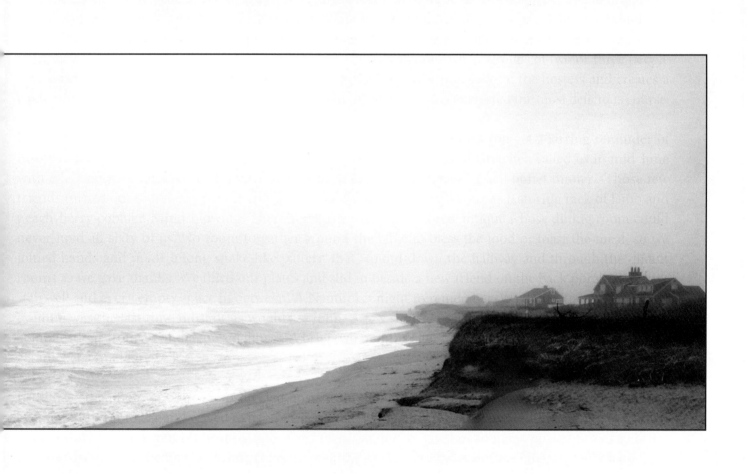

The Big Dig

In their hit song "Built to Last," the Grateful Dead croon that some things are *"built to last while years roll past like cloudscapes in the sky, show me something built to last or someone built to try."* I wonder if any of "The Dead" (as loyal "Deadheads" refer to them) ever visited Nantucket and wandered the streets of the old Historic District? If so, they likely took note of the long-standing and timeless architecture of the historic homes – some dating back to the mid-1600's. Tenants and first time Nantucket homebuyers are often pleasantly surprised to discover how well-built the homes were in the "good old days". Recently, I heard a local builder describe a 1700's home as having "good bones." That's contractor speak for "built to last."

As real estate changes hands on the island and new owners are provided an opportunity to bring their own sense of style and design to the antique homes, it's both exciting and intriguing to watch these houses undergo a transformation. Within the Old Historic District, the Historic District Commission (HDC) helps ensure that original architectural design and integrity of the homes is preserved while giving new owners the freedom and flexibility to bring their own contemporary vision and lifestyle needs to the historic dwellings.

On some of the smaller lots in town, ingenuity is the name of the game. One of the projects I enjoyed watching evolve was the restoration of the antique home at 26 Fair Street. The new owners apparently wanted more living space than the quaint home afforded, so they simply jacked the house up and dug a full basement under it. This is a common practice on the island where additional footprint or a second dwelling may be restricted due to the size of the existing lot. Even with the addition of a new foundation, which could potentially alter the exterior appearance of a house, there are creative ways to preserve the original design and elevation of a property. A local architect told me recently about a historic restoration his firm was just completing. He said the exterior foundation of the home had all of the original "rubble" dating back some 200 years, so when they sought approval to raise the house to pour a basement, it came with the contingency that the "rubble" be preserved…down to the last stone…and put back in almost identical fashion to what it was before. The project is now almost complete and if you didn't know there was a brand new full basement underneath you would never guess by the exterior appearance.

Building a basement under an antique home isn't just about creating additional living space. It's also about homeowners putting a solid foundation under the age-old dwellings…"shoring" them up and ensuring that in another 200 or 300 years they will still be solidly intact. These houses still have "good bones" but now have solid concrete reinforcement as well.

The next time you find yourself in Nantucket's Old Historic District, spend some time lingering outside some of these antique homes. Admire the unique architectural design, features and building materials. If you're in the market for your very own Nantucket treasure, but concerned about space constrictions, engage one of the island's architects or builders to discuss creative options for maximizing its renovation. Start with the "good bones," add in some contemporary upgrades, perhaps pour a new foundation and then continue the long-standing Nantucket tradition of creating homes that are built to last.

Dig deep.

Beach Bliss

"My life is like a stroll on the beach...as near to the edge as I can go." --Thoreau

To those of us who know, love and frequent the Nantucket beaches, it comes as no surprise that National Geographic's book "The 10 Best of Everything" named Nantucket's beaches some of the top ten best in the world. I suppose the only surprise to those of us deeply devoted to our island's sandy shores is the fact it was Number six instead of Number one.

If you live here or frequent the island, you no doubt have a favorite beach or perhaps a "best kept secret" slice of sand that few others have discovered. Some days it's fun to join throngs of other "beach bums" and check out who has the season's coolest beach gadgets or who's wearing the most outrageous swim trunks. If you are like me, there are other times it's nice to just take your book and beach chair and find a sliver of solitude for a few hours as you let the warm sun and cool sand rejuvenate your soul.

There is a mystique about the beach experience that is hard to identify. What is it about the zillion granules of sand and the boundless ocean that entices us humans to leave our 4 walls and clamor to be part of it? I suspect it's because it so powerfully affects our 5 senses. The beauty of the water and sky, the aroma of the ocean air and beach roses, the sound of the waves as they crash against the shore, the taste of salt water from the overspray and the feeling of that cool sand between our toes. Few other experiences simultaneously stimulate all 5 of our senses the way an afternoon spent seaside does. You virtually never see anyone having a bad day at the beach – it's a happy place.

The intrigue of the beach goes beyond its beauty. Without warning it can gobble up your possessions. I've watched friends lose cell phones, sunglasses, keys and children's pacifiers. A treasured item is dropped, a little sand gets stirred up and the next thing you know the coveted belonging sinks into a black hole in the center of the universe. I'll bet you have a story of losing something precious on a beach in Nantucket.

Every now and then you hear a happy ending or a "believe it or not!" story. I have one. A few years ago my daughter Ashlie left a sentimental blue topaz ring (a cherished 13th birthday gift from her dad) wrapped in a t-shirt on top of her beach towel. She didn't miss it until she returned home. The family/friend search party was called out and a caravan to the beach ensued. Everyone fanned out with eyes riveted to the sand... hoping against hope to spot something shiny. No luck. Three days and two million tears later, we returned one last time to that expansive stretch of golden sand hoping we could defy the odds. We congregated near where she thought her beach towel had been. Just as we were preparing to dig to the center of the world, my daughter-in-law Melissa brushed her sandal across the sand and "tada!" the sparkling ring miraculously appeared. More tears, several high fives and a few "what are the odds?" later and we all paused at the waters edge to consider how serendipitous life really is.

The next time you find yourself on one of Nantucket's beautiful beaches, take a stroll along the shore. Inhale the salt air. Let your feet sink deeply into the sand. Gaze out at the expansive ocean and reflect on the wonder of it all.

Ahh...bliss.

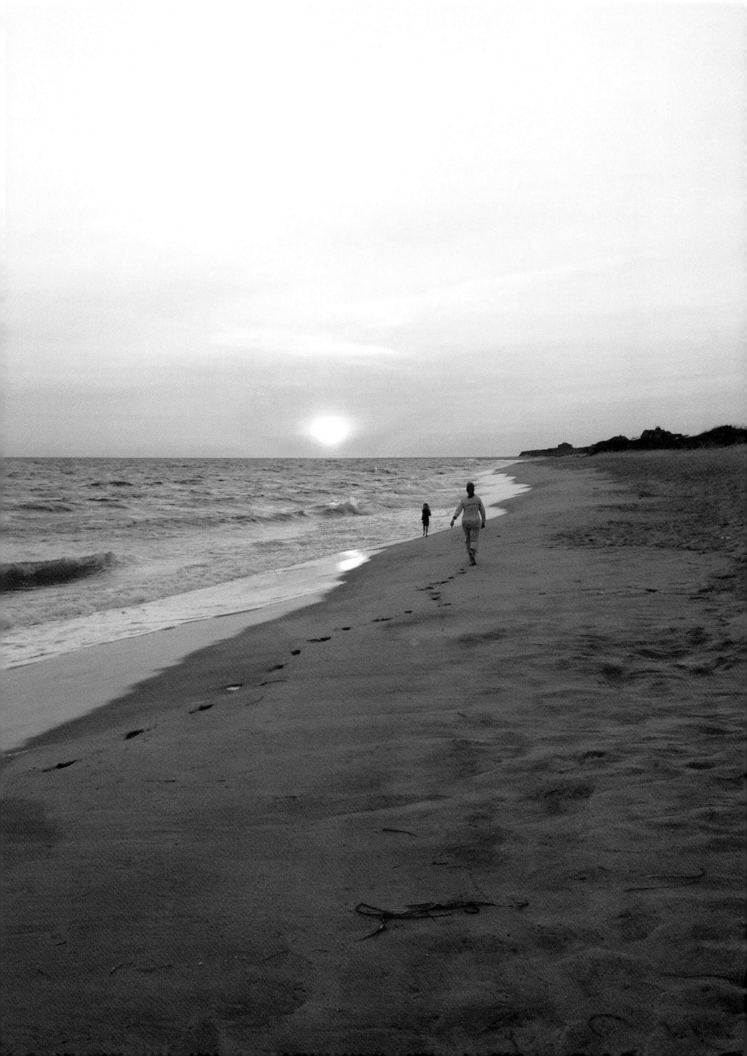

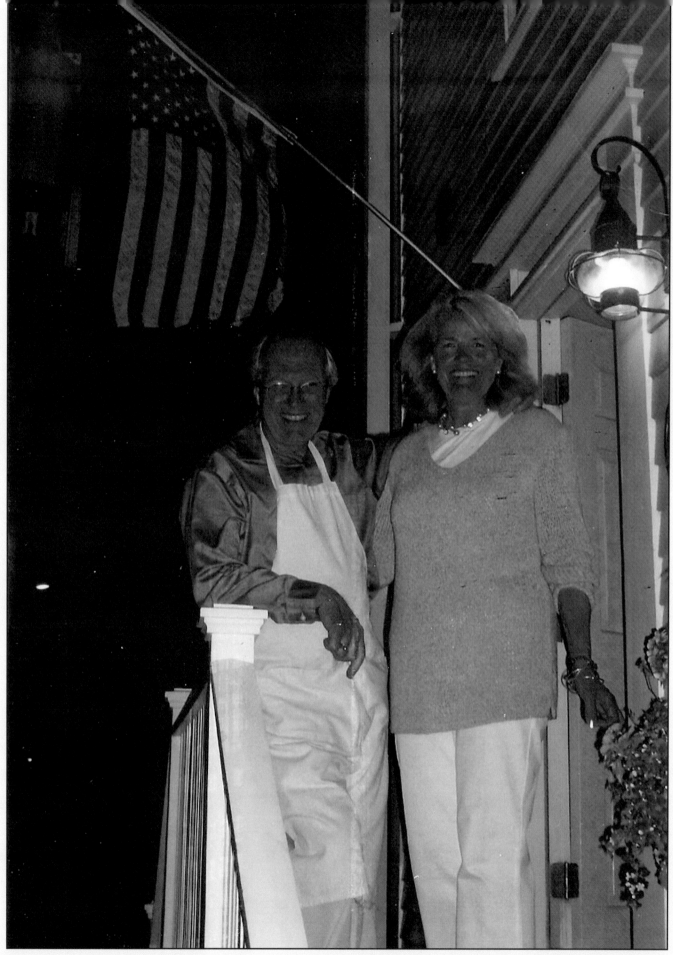

Perfect Nantucket hosts, John and Gretchen Schymik

Guess Who's Coming to Dinner?

Remember the Stouffer's commercial from the 80's where the husband sits in awe at the head of his beautifully adorned dining room table? "So this is the dining room," he quips as his wife serves the Stouffer's meal on the fine china. We all chuckled because we could relate. It seemed our days gathered around the dining room table using the "good" dishes and crystal were quickly becoming a thing of the past. Then Erma Bombeck came along and reminded all of us life is short and we should pull the fine china out for every meal and gather our children around the dining room table as often as possible.

I love all the Nantucket restaurants, but there is perhaps no finer place to dine than at the home of a friend or my own dining room. I can safely say that 90% of all the relationships I've developed on this island originated at a dinner party. I love how each one is unique. Some friends pull out all the stops – tablescapes and five course meals. Others opt for casual fare and plastic utensils. One friend taught me the fine art of the "cook together." The hostess provides all the ingredients and creates stations where groups of two or three people who don't know each other work together to create a dish. It's great fun, easy on the hostess and creates a competitive spirit that flows over to the table where guests brag about who created the most delicious course.

I find that every dinner shared with friends is meaningful, but sometimes you get a jarring reminder of how precious these gatherings are. A few years ago our friends John and Gretchen called us in mid-June with a last minute Sunday night invitation to join "a few friends" for a "casual buffet dinner." Those few friends turned out to be sixty people and the casual dinner was several courses featuring rack of lamb and peach-berry cobbler. Mind-blowing. Their home is a lovingly restored antique whose dining room could never hold all sixty of us. No room to gather around the table to bless the food or toast the meal, so we joined hands and made a long snake like pattern that wound down the hallway and through the quaint rooms as we gave thanks. We filled our plates and slid in beside a new friend on the back porch, the front stairwell and every empty space in between. A Nantucket night to remember. We didn't know that special evening was the last time most of us would see John. A few short days later he was rushed off island with complications from an undiagnosed illness. A brief two months later he would depart Planet Earth and bid Nantucket a final farewell.

I still have the photo of our two apron clad hosts from that evening standing on their front porch as they beamed from ear to ear and waved to us as we departed. Every time I see it, it reminds me not to turn down a dinner invitation or put off hosting one of my own. Nantucket gives us so many opportunities to bring friends together for the formal dining experience or the casual clambake. But the fare is never what's truly important. Whether it's Stouffers or local Nantucket lobster, the purpose of the dining room event is to gather friends and loved ones for an evening of laughter, celebration and memory making.

Each summer whether you are a Nantucket resident or short term visitor, be sure to make your way to the dining room table – your own or one of a friend. Share some laughs, break some bread and raise your glass to toast the island that gathers us around its collective table.

Dinner is served.

AUGUST

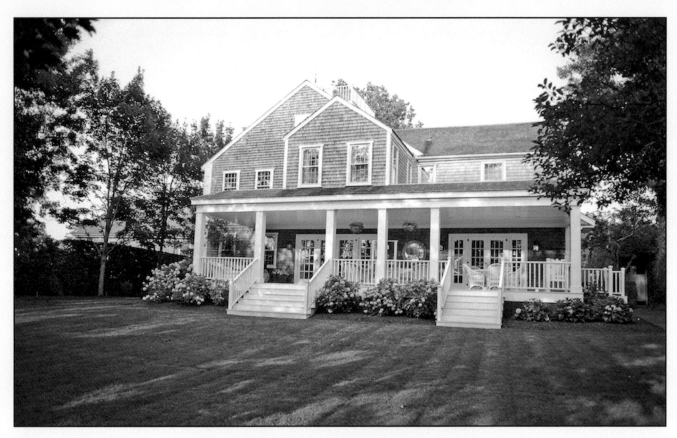

Original Captain Reuben Bunker house, circa 1800's

Captain's Quarters

It's well known that Nantucket was once the whaling capital of the world. Crews would board the large whaling ships and set out to sea in search of those beautiful spouting creatures...their money-makers. Although the boats were not all the same and the crews varied in size and skill, there was one common denominator among them. Every ship had a captain. The man entrusted to chart the course, inspire the crew and command the vessel. The guy in charge - the go to guy.

It's no wonder these Captains were held in high esteem by the people of Nantucket. Their responsibility was great and the benefit they provided to the community, as the whaling industry flourished, was profound. They would set sail and be out to sea for months, sometimes years, at a time. The lives of the captain and crew out at sea, while lucrative, were wrought with danger, isolation and exhausting labor.

Nantucket has dozens of historic Captain's Houses in its registry. For the most part, we know very little about the captains themselves. One of my jobs as a real estate agent is to research the properties to unearth the historic background, owners and any interesting tidbits. Recently while digging for some information on a home on Academy Lane, I found this little snippet about Captain Reuben R. Bunker, the original owner. "Reuben R. Bunker was a whaling captain and an important man in the town, as shown by the fact that his signature appears on many records, petitions, etc." There you have it. No mention in this journal entry of his ship, his crew or his career or even which documents he signed...just significant that he was chosen to sign them.

I find it fascinating that for all the great feats these captains accomplished, the whales they speared, the ships they commanded...the only real tangible evidence we have left to give us a peek into the lives of these men is their homes - where they lived, raised their families, entertained their friends and enjoyed a little reprieve from their difficult sea lives. The houses don't tell us everything about the captains, but they tell us something. Some were trendy. Many of their homes were built in the design of the times - Federalist or Greek Revival. They were creatures of innate detail. Many of the homes have customized dentil moulding along the covered porches, crown-moulding adorning the ceilings in every room, elegant fireplace mantels and beautiful wood floors. It's evident they placed high value on the comfort and lifestyle of their wives and children, sparing little expense and few luxuries to ensure they had a functional and beautiful place to reside while the man of the house was away at sea.

There are some questions the house itself cannot answer...things I wonder about as I walk through to snap some photos or write some ad copy. As I linger in the dining room, I consider who the honored guests were at this captain's table and who was chosen to fill the coveted seat next to him. In the small study, I reflect on the letters he might have penned to the wives of his men lost at sea. As I wander through the children's rooms, I imagine their delight to have their father home, even briefly, for bedtime stories and goodnight kisses. I envision quiet late night conversations with the wife who held the home together in his absence, as they sit fireside in the parlor...grateful for their time together. (Yes, I'm a romantic, humor me.)

These Captains homes are a gift to our island. Beyond the whales harpooned and the ships commanded, we are left with the place the captains and their families lived their lives. Stop by the Nantucket Historical Association to see what interesting facts you can uncover about Nantucket's famed captains and their quarters. Step back in time and embrace the islands history.

Aye Aye Captain!

A Garden Party

My husband Dan and I were humming Ricky Nelson's 1970's Billboard hit as we left our first garden party of the season. And what a party it was! The Artists Association of Nantucket held its annual Gala on the lawn of a stunning Hulbert Avenue estate, generously donated for the evening by a long-time supporter of the organization. Mother Nature was in full cooperation with blue skies, tolerable late summer temps and a gentle breeze. Even the mosquitos and green backs were well behaved and took the night off.

As we entered the expansive back lawn through the proverbial garden gate, the beauty of the transformed garden almost took our breath away. I found it fitting, since the event was to benefit the Artists Association, that the garden truly looked like a work of art. Dozens of tables were adorned with floral tablecloths, fragrant centerpieces and elegant place settings. There was a large tent erected to tastefully display all of the donated art pieces, as well as allow for an expansive array of pre-dinner hor'dourves stations and the always popular raw bar. Every thoughtful detail created a warm welcoming atmosphere making guests feel right at home.

One of my favorite things about summer is the opportunity to do life outdoors. All over the USA folks find unique ways to host social gatherings in their outside spaces. I'm an Iowa girl, so while not originally familiar with the garden party concept, I am no stranger to an outdoor cookout. It was almost a nightly summer event. After work, friends or neighbors would stop over with some fresh garden tomatoes or homemade potato salad. We'd pop the top on a can of Budweiser, put it in the rump of a farm raised chicken and stick it on the BBQ grill. We'd sit around in lawn chairs sharing stories about our day and some evenings half the neighborhood would be gathered on one lawn or another before the night was out.

Eventually we moved to Arizona where the backyard BBQ was affectionately (and accurately) referred to as the pool party. No need to include a dress code on the invites...actually no need for invites at all. Same casual "drop by" attitude as our Iowa neighborhood. Friends would stop over after work in their swimwear and flip flops (Arizona attire eleven months of the year), bearing armloads of chips and salsa, brimming pitchers of lemonade or margaritas and a platter of burgers or hot dogs. Our kids would swim until their skin turned to raisins and their hair turned green from the chlorine. The adults would moan about the heat and then toast the good fortune to have neighbors who make it tolerable.

Ricky Nelson had it right when he said he went to the garden party to reminisce with his old friends. That's truly the best part of any outdoor social affair. The AAN Gala was no exception. The garden party event was a big success, showcasing brilliant work from dozens of local artists. A lot of money was raised to fund the many programs they offer and young artists they support. Like Ricky, we were delighted to run into many island friends we hadn't seen all summer. It was fun watching all the artists interact with each other and meet some of their fans and collectors.

If you haven't made it to a Nantucket garden party recently, check the island calendar to see if there is one coming up. Or, how about creating an impromptu one of your own? Partner with an organization to host the party to benefit a good cause or simply throw together a casual neighborhood cookout. Take advantage of the dog days of summer to reminisce with old friends.

It's all right now...

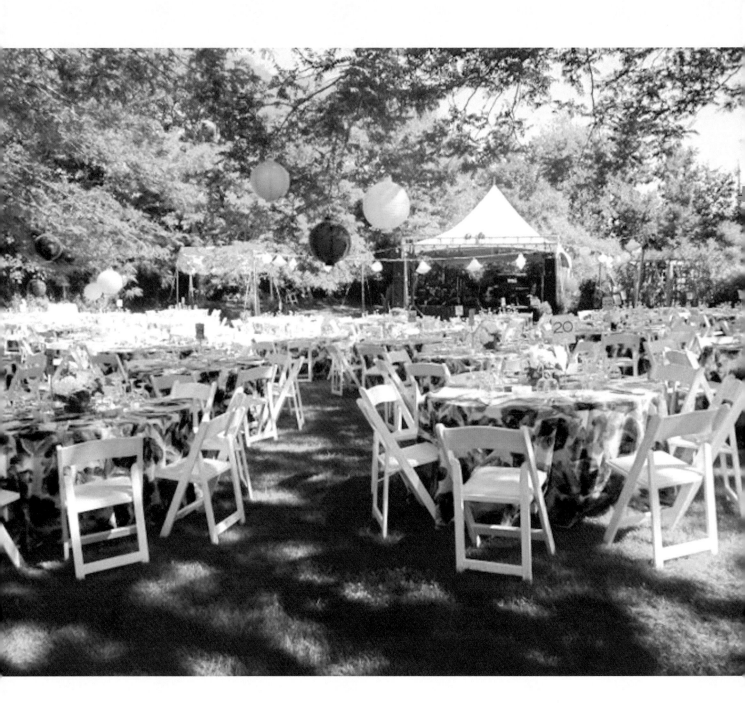

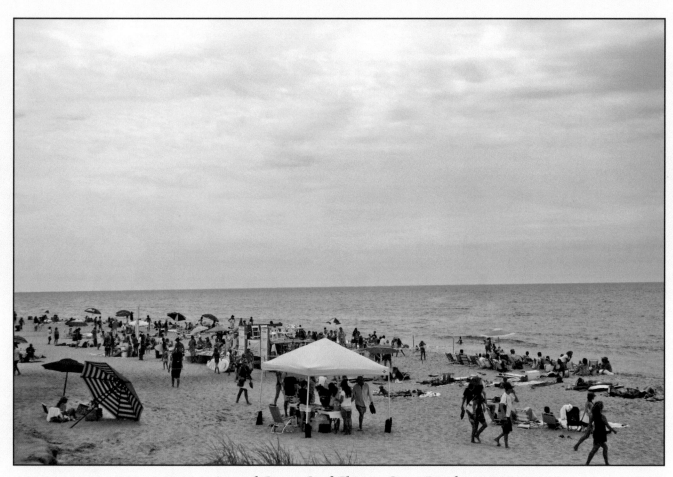

Annual Ozone Surf Classic, Cisco Beach

Surfin' ACK

The Beach Boys convinced us that *"if everybody had an ocean, across the U.S.A., then everybody'd be surfin' like Californi-a."* I think that might be true. If you hang out on any beach long enough, watching nimble surfers gracefully riding the waves, it makes you wish you were skilled enough to "Hang Ten" with the best of them. At the very least, you feel compelled to dive in and catch a wave.

Surfer dudes are cool. I envy the way they're tan and relaxed. They always have lots of friends...other cool surfer types who share their passion and speak their language - and what a language it is. I did some research on "surfer speak" and determined I'm too old and nowhere near hip enough to carry on a conversation with the "cowabunga" crowd.

Dangerous surf translated is "gnarly," exhausted is "noodled." You're a "paddlepuss" if you stay close to shore; if you and your friends all catch the same wave at once it's a "party wave." If you own some fashionable surf gear or clothes but have never surfed you're a "shubie." Fall off your board and you'll surface to shouts of "wipe-out!" A "fakie" is someone who rides backwards on the surfboard OR someone who researches surfer talk so they can pretend they know about surfing. I fear I may be a fakie.

The Ozone Surf Classic is held each summer on Cisco Beach. Hundreds of surfing enthusiasts gather on the sand to participate in this special event started a few years ago to celebrate the life and memory of local islander and surfer David Ozias. They raise money for island charities that support kids.

Dave Ozias was the ultimate cool surfer. His parents are dear friends of ours and we were saddened when his life was cut tragically short at the young age of thirty. Dave had a warm smile, some "fierce" long dreadlocks and a huge heart that reached far into the Nantucket community. Stories continue to surface about the kindness he shared with most everyone he met. One of my favorites was told by a Jamaican worker at Dave's funeral. He said the first time he met Dave it was a frigid March Nantucket day complete with sideways rain and biting wind. The worker was finding it tough to acclimate. Dave inquired how he was doing. The guy replied, "I'm cold and I'm hungry." Without hesitation Dave took off his sweatshirt and gave it to him and walked over to the pharmacy and bought him a sandwich. Now that's a wicked cool guy at his finest.

It's fitting that this annual event celebrates such a good guy and his love of the surf. Consistently dubbed one of the top surfing destinations in the country, Nantucket waves promise to thrill the skilled surfer or the casual observer. If you haven't already done so, make your way to Cisco, Nobadeer or Surfside. Bring along a surfboard or rent one. Don't be a "shubie" or a "paddlepuss," dive right in and join the "party wave."

Hang ten.

Running With The Wind

Nantucket is awash with beautiful scenery in the summer time. Virtually everywhere you turn there are "Kodak moments" to behold. One of my favorite summer scenes is the harbor brimming with boats of all shapes, sizes and design. It's so serene to watch some glide through the jetties on a cloudless afternoon and others bob on their moorings as they obediently turn into the wind.

During race week there is an inordinate number of sleek vessels gracing the boat basin. The Opera House Cup Regatta is kicked off by one of the highlights of the day - the classic parade of Nantucket's Rainbow fleet around Brant Point. The brilliant colored sails dance along the shoreline as the water laps against the sides of the boats. Watching the scene unfold from the beach is like watching an artists brush sweep across a canvas. Nantucket days are like that...you sometimes feel as though you are part of an animated work of art.

Sailing in general is its own style of artistry. Each boat unique in its design, constructed of beautiful wood or stark fiberglass, outfitted with a variety of rigging and sail configurations and any number of gadgets and gizmos to help ensure it sashays across the water with ease. Captain and crew (even a small crew of one or two) make the sailing event look like a dance...every motion in sync, gracefully and artfully manipulating the vessel with full knowledge the wind has the final say.

I've been both a passenger and a crew member on a sailboat. As a passenger, experiencing the lull of the motion, the sparkling beauty of the open water and the sound of the splashing waves, I find complete peace. As a crew member...well, not so much.

My husband is a seasoned sailor, having spent two years post-college sailing the waters off the east coast and Bahamas. Fifteen years ago, when we purchased our first boat together (a 26 foot cutter-rigged sloop), it was his fondest wish that I would come to share his passion for sailing and quickly become an accomplished First Mate. I'm a fairly quick study, but prefer to be methodical and detailed in tackling new endeavors. So imagine my wide eyes and racing heart the first time the two of us climbed aboard Destinie for our first "two man" sail. It was trial by fire. I was unprepared for the necessary rapid-fire commands that commenced the moment we cast off the mooring line. "Hoist the main, raise the jib, watch the boom, cleat off the main sheet, prepare to come about!" Huh?? Which one is the main and what's a sheet? Needless to say I looked a bit like Lucille Ball in a candy factory and there were a few dozen knots in the lines before we finally got everything shipshape and were able to enjoy our first Nantucket sail. It's a good thing the Captain had patience.

Ultimately, I graduated from Sailing 101 after many stressful sessions on the open water and eventually became a pretty good First Mate (yes, I now know where the main is). There is just nothing better than experiencing the beauty of Nantucket Island from the deck of a sailboat. You can travel all along Coatue, all the way to Great Point and back. The island takes on a whole new persona when viewed from offshore. Before the summer draws to a close, why not schedule some time to sail the waters around Nantucket? Crew your own craft or one of a friend, rent a boat or charter an excursion.

Set sail.

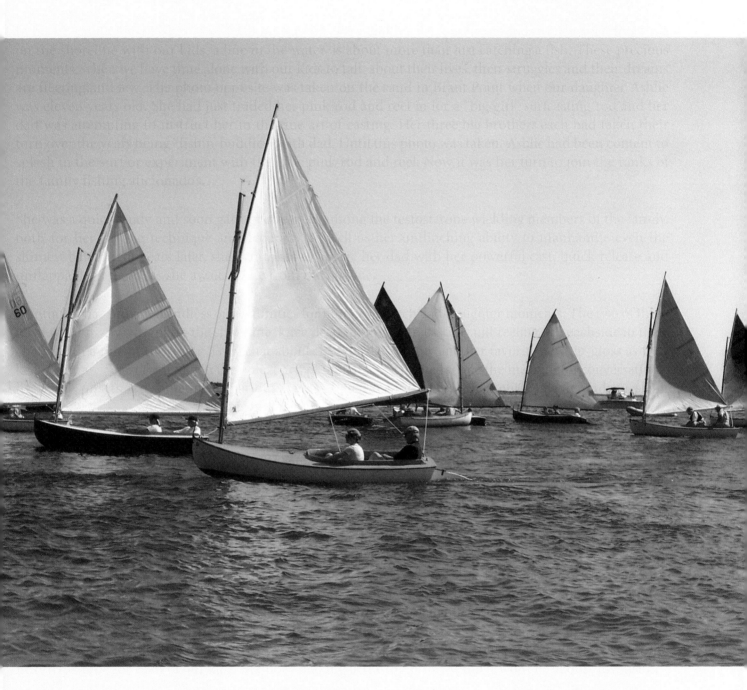

Photo courtesy of Sosebee Studio

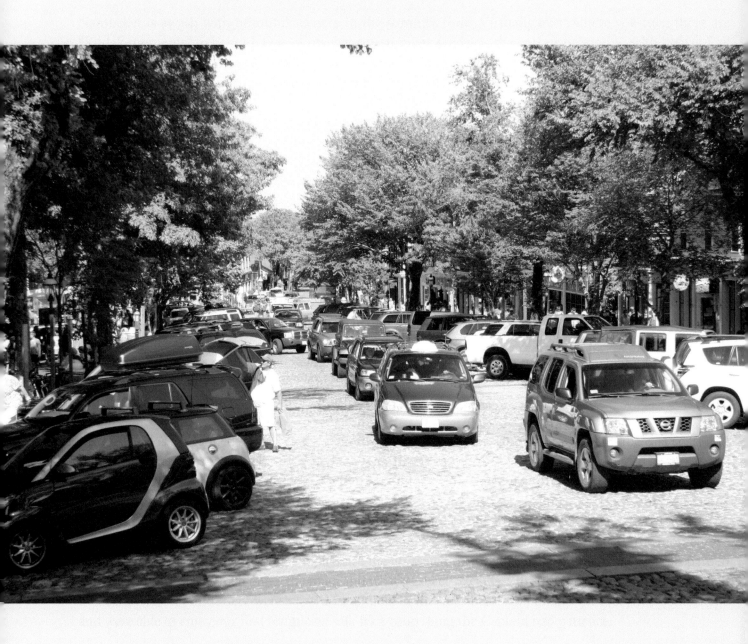

Dude Where's My Car?

The 2000 cult classic movie starring Ashton Kutcher is the outrageous story of two teens who party a little too hard one night ending up in what they describe as a "chemically induced coma." This results in severe short-term memory loss. For those of us who live and work on Nantucket full time, August tends to place us in a similar state of mind best described as a "chaos induced coma." All of the service industries work double time during this season, where one day runs into the next, minutes run into hours, morning becomes night and before you know it you are blurry eyed, disheveled and some days downright confused. What day is it? What time is that next appointment? Where in the world did I park my car?

Downtown parking is a continual point of conversation on the island. Regardless of the varying ideas being circulated on how to improve the dilemma, one thing locals and visitors alike must contend with during the summer is where and how long to park their cars. There are some great options for those who don't need access to their vehicles throughout the day; bikes, scooters, taxis or the local island shuttle system (NRTA). In the real estate business, we have no choice but to have our cars nearby. On a moment's notice, a client can call or walk through the door wanting to see a house across the island. With the in-town parking zones set at one or two hours, we've all perfected the fine art of "musical cars." We set our egg timers for the allotted time, sprint out the door as the buzzer sounds, hoping against hope to reach our autos before the chalk bearing men and women in gray clad uniform do.

Some days I look out from my second story Main Street window and it looks like the opening scene from Chariots of Fire. Other real estate colleagues and local shop owners race against the clock to move their cars before receiving the dreaded orange parking ticket on their windshield. Many days we are victorious, but most of us have a little collection of the carrot colored beasts indicating we weren't quick enough off the starting block. My friend calls this the cost of doing business.

As cars get shuffled throughout the busy days, it's very easy to get disoriented as you leave work in the evening. One recent summer evening, my husband Dan and I walked out of our office, looked at each other and said, "where's the car?" Neither of us had a clue...could not even remember which one of us had driven it last. We knew it couldn't be far, so we devised a "divide and conquer strategy." He would walk up Orange and down Fair. I would peruse Main Street, then cut across Federal and back down Center. We met fifteen minutes later back where we started - no car. We sat down on the steps outside our office and began to laugh - a fine state of affairs. Were we really this old or had our chaotic life finally fried our brain cells? What to do now? We could concede and cab home. We could throw a fit, kick and scream and hope somebody would care. Or, we could simply find a way to make the best of it. "Queequeg's or Ventuno's," Dan inquired with a grin? Ah yes, a little lite bite and a beverage (or two) at one of Nantucket's outdoor dining establishments would help the medicine go down.

We slid onto a couple stools outside at Queequeg's, befriended the outgoing bartender and array of other alfresco diners. Before the night was out, we had several new friends, two new client prospects and a delicious meal...and to think our original plan was to hop in the car and spend the night at home! As we

were finishing dessert, Dan enthusiastically blurted out, "Winter Street!" Huh? He remembered he had moved the car to Winter Street late in the afternoon. Our new friends all whooped, hollered and raised their glasses in celebration - they could relate.

The next time life serves you a little "chaos induced coma" and you find yourself blurry eyed, run ragged or a bit overwhelmed, find a way to slow down and make the best of it. Or, as the lady on the GPS device says "recalibrate!" If you're lucky enough to be on Nantucket when this phenomenon strikes, you have a myriad of options to choose from. Take a walk on the beach in Cisco, stop out to Madaket at sunset, sip a cup of java on a harbor-front bench at daybreak or slide onto a barstool at any one of Nantucket's fine restaurants and make some new friends.

<div align="center">Enjoy the Journey!</div>

SEPTEMBER

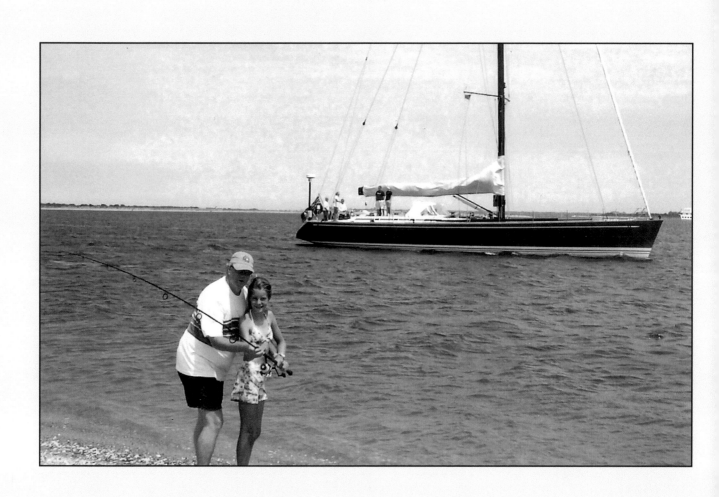

Just Fishin'

In his hit single, "Just Fishin" Trace Adkins tugs on every daddy's heart as he reminds us that spending time on the shoreline with our kids, a line in the water, is about more than just catching a fish. These precious moments, when we have time alone with our kids to talk about their lives, their struggles and their dreams are fleeting and few. The photo opposite was taken on the sand in Brant Point when our daughter Ashlie was eleven years old. She had just traded her pink rod and reel in for a "big girl" surfcasting rod and her dad was attempting to instruct her in the fine art of casting. Her three big brothers each had taken their turn over the years being "fishin' buddies" with dad. Until this photo was taken, Ashlie had been content to splash in the surf or experiment with the little pink rod and reel. Now it was her turn to join the ranks of the family fishing aficionado's.

She was a quick study and soon garnered respect among the testosterone wielding members of the family, both for her casting technique and accuracy, as well as her unflinching ability to manhandle even the slimiest bate. Eight years later, she continues to amaze her dad with her powerful cast, quick release and unflappable patience as she awaits a bite from the big one.

Nantucket has provided endless opportunities for numerous such dad/daughter moments. The two of them have spent many a night on the shoreline, knee deep in the water, casting and reeling or beachside in their chairs with a line in the water. They chat about the world economy and her favorite new lip-gloss as they keep their eyes alert for a tug on the pole. Each of them has recounted to me the meaningful conversations, beautiful sunsets and sometimes hilarious events of their fishing dates. One night, while in Madequesham at sunset with a few additional fishing buddies, my husband had a live one on the line. Ashlie and the others cheered him on as he reeled in dinner. As the catch landed on shore they discovered it was a large pair of women's blue underwear. The small crowd howled with laughter and my husband humbly tossed his catch back in. An hour later he caught the exact same "fish" again! My daughter loves this story. A year later he redeemed himself when he caught a small sand shark in the same spot on an equally beautiful Nantucket night. Fish or not, these memories are in the hearts and scrapbooks of both dad and daughter.

Years later, Ashlie and her dad left rods and reels behind and headed south on a "road trip" to North Carolina where she was entering her second year of college at Elon University. It was a bit surreal to think how fast time had gone, how quickly she graduated from the little pink rod and reel to the "big girl" surfcasting rod and then to college life with less and less time for treasured one on one moments with dad or mom. The two of them made the most of their three-day dad/daughter trip, squeezed into her little VW bug surrounded by all things college girl. They made new memories at road-side cafés and outlet malls and together decorated her new apartment. The nest is empty once again, but plans are underway for the next trip home for each of our kids. Memory making is the top priority and it won't be about "just fishin."

Whether you're a Nantucket resident or a first time visitor, be sure to purchase or rent a couple surfcasting rods or maybe a little pink or blue rod and reel. At the top of your itinerary write the words "time alone with my son or daughter." Savor these precious moments while you can, make some Nantucket memories and hug your fishin' buddy as the sun sets.

Go fish.

Here Comes The Bride

"I used to think a wedding was a simple affair. Boy and girl meet, they fall in love, he buys a ring, she buys a dress, they say I do. I was wrong. That's getting married. A wedding is an entirely different proposition." So said Steve Martin during his famed monologue in the movie "Father of the Bride." Several lines from the movie were playing in my head this week as I stumbled upon two different Nantucket wedding scenes (rumor has it there were thirty-five weddings in total!) There's something about a new bride adorned in her wedding gown, bright smile gracing her face, that stops traffic. This was the case outside St Mary's recently as I made my way down to the post office. I joined the curious crowd of onlookers gathered on the sidewalk, spilling into the street, anxiously waiting the appearance of the bride and groom. We all oooed, awed and applauded in unison as the happy couple emerged and made their way down the steps - a group of friends, loved ones and strangers collectively wishing them a lifetime of happiness.

Nantucket is an easy place to experience romance - many ways and places to fall in love and celebrate life. Every beach offers its own allure where couples can stroll hand in hand at sunrise or sunset. For the athletic minded duos there are beautiful golf courses, several tennis courts and a number of bike paths for exploring the island. Virtually all of the restaurants advertise that "cozy table for two" perfect for intimate dining. Post dinner, couples can meander up and down the quaint streets to admire the historic homes or slide onto a bench to gaze at the harbor.

The Nantucket wedding provides the perfect opportunity to share this beloved island with others. I remember when my cousin Vince and his wife Melissa were married here. It had been a few consecutive days of torrential rain. Just thirty minutes before the bride and groom were scheduled to arrive at Brant Point for the ceremony, the clouds parted and they said "I Do" as Mother Nature blessed their union with a perfect late August sunset. A few years later, my friends Carolyn and Ben exchanged vows. We flew in for the much-anticipated occasion along with dozens of their friends and family. Each activity of the weekend outdid the one before, as a multitude of friends and loved ones gathered harborside for cocktails one night and on the lawn of the Sankaty Clubhouse the next. We traded stories with fellow guests about our favorite Nantucket experiences. Who caught the biggest fish, had the best golf shot or took their first midnight dip in the ocean. The events culminated with a collective clink of the champagne glasses in celebration of the beautiful bride, her dapper groom and their new life together. Nine years and two kids later the happy couple are still going strong and daily creating fresh memories. Nantucket provides the ideal backdrop for living happily ever after.

If you're searching for a romantic getaway where new love can blossom or old love can be rekindled, look no further than this intimate island. If a wedding is on the horizon, Nantucket offers the scenery, amenities and services to create an event that will be forever embedded in the lives and hearts of wedding party and guests alike. Be sure to make this faraway island your next romantic destination and come prepared to experience love.

I do.

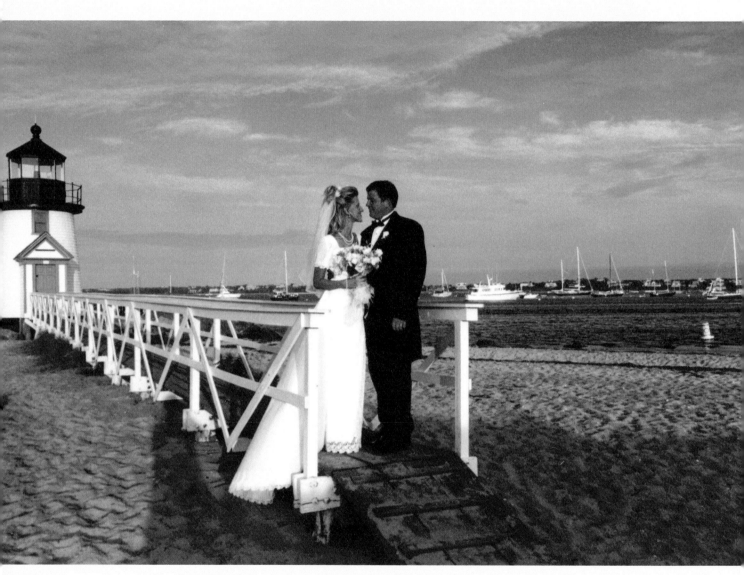

Bride and Groom Vince and Melissa Rainforth

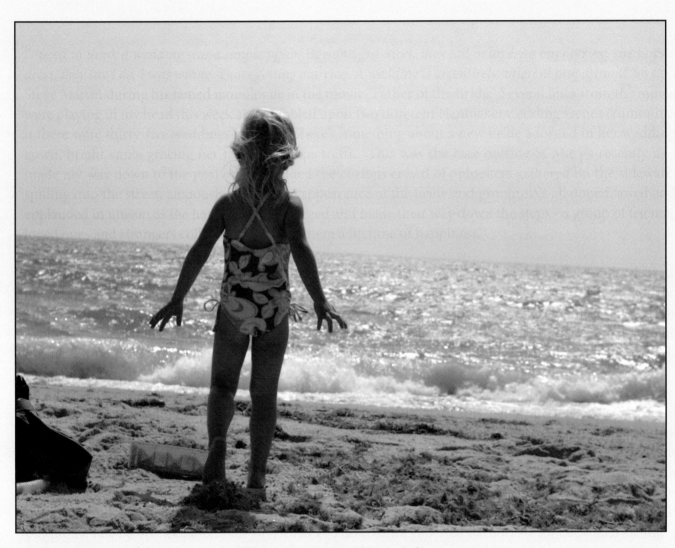

Madison Tobie Dunlap, age three

Papa's Ocean

Peter Pan says if growing up means it would be beneath his dignity to climb a tree, then he refuses to ever grow up. One of the most amazing things about Nantucket is it brings out the child in all of us. I had the opportunity recently to experience Nantucket through the eyes of our granddaughter, Madison Tobie. It was a week of firsts for her. She had never been on a six-hour flight, never been on a ferryboat and never seen the ocean. She landed on Nantucket wide-eyed and full of questions. Where's the beach? Why do you have so many rocks on your road? When will we see a whale? Her dad reported that she'd been duly impressed with her first glimpse of the Atlantic Ocean as the ferry pulled away from Hyannis. She's believed since she was tiny that "Grammie and Papa" somehow live IN the sea and had much anticipated her first visit to what she calls "Papa's Ocean."

Every place and experience we introduced "Tobie" to raised her curiosity. Narrow winding streets lined with one charming grey house after the next. ("Is grey Nantucket's favorite color?" Tobie inquired.) Miles of sandy shoreline perfect for long walks or sandcastle creation ("Can I bring this castle home with me?" she asked). Secret sand roads meandering through unspoiled moors. ("Grammie," Tobie wondered, "are you the only one who knows about the secret road?") Some days, especially in the shoulder season, it feels like it. Nantucket is full of secret places I assured her.

There are bigger questions to consider. As the thick fog rolled across our back lawn, Tobie wants to know if we can eat it (an Arizona girl has only seen white fluffy matter dressed up like ice cream or cotton candy). As she spotted her first seal off Cisco beach she wondered who feeds them and where they sleep at night. Speaking of seals, "why does the Nantucket "zoo" have seals, fish and seagulls but no penguins?" she pondered. "Penguins would love Nantucket," she concludes. I suspect she's right.

Our days with Tobie re-opened my eyes to the many intricate and unique features of this little island. I realized how many things I take for granted each day. I've developed a new discipline of observing my surroundings and contemplating what Tobie would have to say about them. This beautiful island is inspiring and sometimes you have to view it through the eyes of a three year old to renew your sense of awe. Like most of us who visit Nantucket for the first time, Tobie has been romanced and hoped to take a little piece of it home with her. As her daddy was packing for their departure he noticed her little purse was heavier than when they arrived. She'd snuck a few handfuls of the Nantucket beach and a dozen seashells into her bag. The island had stolen her heart.

It's been said that Nantucket is a playground for grown-ups. The next time you find yourself wandering the streets or strolling the beaches of Nantucket, tap into your inner child. Build a sand-castle, order an ice cream cone (or two!) or ride a bike. Take note of the many ornate details gracing the island and ask some innocent questions. Renew your sense of awe, let the island romance you and don't be afraid to sneak a few shells in your bag as you depart.

Never grow up!

Reflection

My husband Dan and I like to celebrate the anniversary of the day we became full time Nantucketers - rounding Brant Point on the Steamship, landing on Nantucket as year round residents. We've arrived on the island before a few thousand or so times (we've owned a home here for almost twenty years), but this time we weren't pulling into the harbor to vacation - we were here for good. We looked a bit like the Beverly Hillbillies, car filled to capacity with family keepsakes, a moving van busting at the seams with a lifetime of belongings and a fat white dog even more delighted than we were to be coming "home" to Nantucket.

The island had a million surprises in store for us. As temperatures dropped, the summer visitors began to dwindle and the foliage fell from the trees, we discovered our little island in raw form was every bit as beautiful as in all her summer glory. As we headed into winter, we frequented local restaurants and community activities, gathered friends together for impromptu dinner parties and embraced the quiet hush that characterizes the off-season months. Before we could utter "cold winter's nap," the temps were rising, the trees were blooming and spring was in the air.

Working in real estate has unearthed countless opportunities to become intimately involved with the geography of the island. Our rental visits and turnovers have led us down remote winding roads to beach cottages in Madaket and bluffside homes in Sconset. Sales showings have taken us from Eel Point estates to the sandy shores of Wauwinet - each home ripe with its own nostalgia and charm and the guardian of a family story.

There is no question the best part of our experience has been the opportunity to meet so many interesting and diverse personalities. Each has a unique Nantucket story. Some have spent a lifetime here, some just discovering it for the first time, but all share a common bond - the love of Nantucket. Many are repeat visitors who make the "Nantucket Experience" an annual event. Others choose the island to commemorate a special occasion. Many families celebrate weddings, anniversaries and birthdays. One mom gathered her entire family on the island to celebrate her son's victory over lymphoma.

Even as I reflect on my history on Nantucket, it's exciting to anticipate what's ahead. Many of you have already planned your next visit to Nantucket. Some of you are planning a trip to the island for the first time or are in the process of purchasing a Nantucket dream home where your family can begin building a lifetime of island memories. Join me in reflecting...and then turn your eyes toward the future where the next Nantucket Experience awaits you.

Onward.

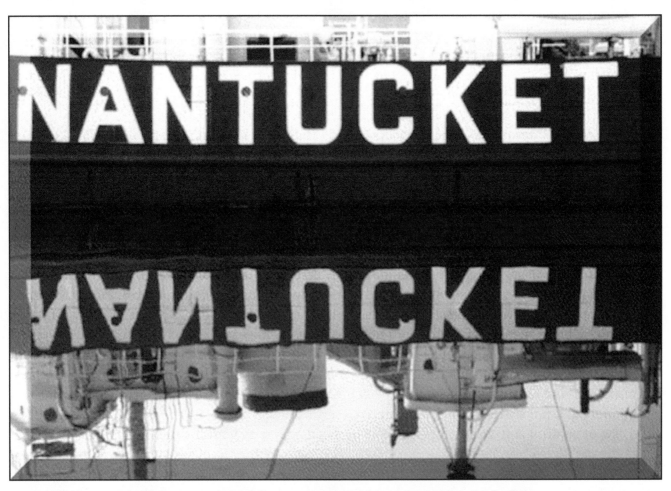

Photo courtesy of Captain Lucas Webster, Nantucket Lightship.

OCTOBER

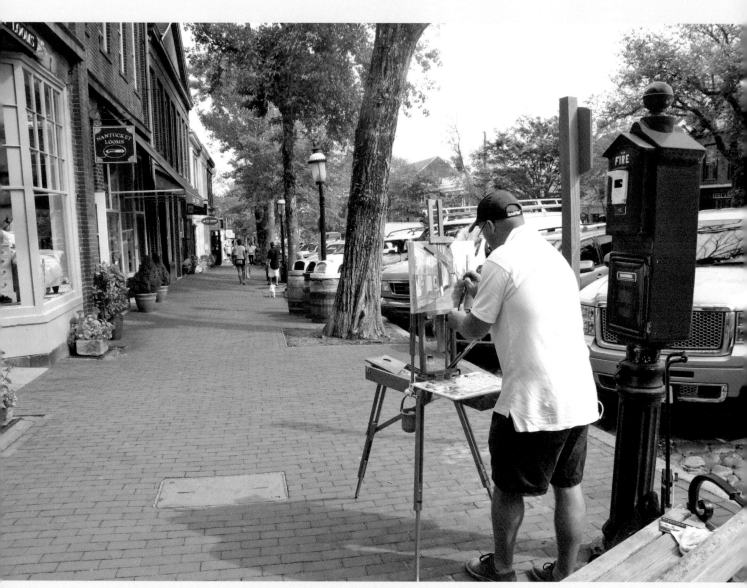

Nantucket artist Christopher Wheat

Paintin' The Town

All across Nantucket, there is an array of charming architecture and breathtaking landscape. For seasoned artistic types and beginners alike, it's a haven to ignite creative juices. On any given day you can spot enthusiastic painters, easels poised "just so," near interesting island scenery. Their paint palettes sprayed with a rainbow of colors, they have an assortment of brushes at the ready and the canvas before them commands their full attention. They draw a crowd, these creative types. There is something quite surreal about watching the real time scene you are living in spring to life before you under the guided hand of the artist's brush.

It isn't just the painters who transform the island's charm and beauty into an art form. There are a number of local photographers, sketch artists, sculptors and graphic designers who use their creative gifts to capture the island's essence. Perhaps most heartening are the stories told by the "newbies" to the art world...those starry eyed novice's who just weeks before donned a camera or paintbrush for the very first time and set out to unearth their inner artist. A few clicks of the camera or swish of the brush later and a new passion is ignited.

Nantucket provides the ultimate canvas to unleash endless amounts of untapped creativity. It also provides countless venues to display the art. A number of galleries, homes and public places showcase local artwork. The Artists Association of Nantucket offers a wide variety of art classes and workshops for all ages. It hosts year round events and gallery exhibitions presenting the work of its emerging and accomplished members. In early October my husband Dan and I attend the "Wet Paint" auction and dinner. A few dozen local painters set up their easels at strategic locations and studios capturing Nantucket inspired images on canvas. During the three-day event, residents and visitors have the opportunity to visit the artists and watch the scenes unfold. On Sunday afternoon, the new creations fresh off the easels and still donning "wet paint", are auctioned off to a throng of several hundred eager art enthusiasts. It is thrilling to watch the crowd boisterously vie for the local works.

One of my favorite places to discover local artwork is in the homes of the artists themselves. Recently I was escorting two sets of parents and a newly engaged young couple on a guided tour of 'Sconset rental homes. In one of the homes, I heard the sweet "bride-to-be" mention to her mom that she recognized the paintings on the wall as the work of the lady of the house - a woman she had grown up knowing and respecting as a local 'Sconset neighbor. I've been in dozens of island homes proudly displaying their owner's creative works. I find it heartwarming to consider what a legacy these pieces will leave for generations to come.

If you have a passion for art - whether it's creating your own or appreciating the work of others - Nantucket is the place for you. Stop by a few of the galleries or the Artists Association of Nantucket to admire local works. Grab your camera or your sketchpad and come let the island inspire you.

Express yourself.

Scallopin'

Just when I thought I had experienced all the "wow moments" this little island has to offer, I unearthed a new one. I found myself giddy as a schoolgirl one recent October weekend as I snagged my first scallop. There's always some friendly buzz around the island as recreational scallop season kicks off. I overheard the banter in the coffee shops and the grocery store lines. "Got a full bushel in less than an hour out in Madaket." "Pickins are slim out in Pocomo." "It's a little spotty off of Hulbert, but give it shot." My curiosity got the better of me. I wanted to know what this scallop chatter was all about.

I love Nantucket bay scallops as much as the next girl (or guy), but I'd never really considered scavenging for my dinner - until recently. I decided the only way to confirm what the buzz was all about was to wade in waist deep and see for myself. Like any respectable sport or hobby, this one requires the proper equipment and attire. I welcome any excuse to shop, so I enthusiastically perused the aisles of Brant Point Marine in search of some adorable waders and a matching rake. I'm certain I was the entertainment of the day as I pulled and prodded myself into the waders to ensure the fit. "Really, they only come in one color?" I inquired. Brown is the THE color this season the nice sales guy assured me with a grin. I couldn't resist asking my husband Dan (who was hiding in the back room hoping no one would realize we were together) "Honey, do these waders make me look fat?" "They were made for you," he quipped and off we went - rakes, basket and shucking knife in tow.

We took to the water, along with several dozen scallop enthusiasts, just off Hulbert Ave in Brant Point. The day was pristine, with near record high temps, the water calm, warm and brilliant azure blue. With no idea what I was doing, I studied the obvious experts in the craft bringing up heaping full baskets nearby. They took pity on the new girl and gave me some helpful tips. There were other scallop novices struggling with their rakes alongside me and together we got the hang of the "sweep, push, dig" motion. Before I knew it my basket surfaced with several of the perfectly shaped gems clinging to the netting. I felt like I struck oil in the Nantucket sound!

I carefully studied the shells to ensure I was keeping the ones with the growth ring (I wasn't about to get busted by the shellfish police my first time out!) I tossed back the "spat" (that's shellfish speak for baby scallops) and proudly continued filling my basket with the keepers. I was unprepared for the sassy attitude of some of these sea creatures. As I reached my hand in to sort them several snapped and spit at me. Collectively they hissed and bounced about in the basket. I've never seen anything like it. My new scallop friends and I chuckled as we compared who had the most unruly catch of the day.

Our scallop skills really got put to the test when the shucking commenced. Experienced scallop friends tell us there's a secret to removing the succulent meat from the shells. It's safe to say, we haven't mastered the technique yet. It took us over an hour to clean enough for dinner, but my-oh-my were they worth the effort. I stepped clear out of my comfort zone and popped a raw one in my mouth before tossing the rest in the frying pan. It tasted like candy. A quick sear in the skillet later and "voila" dinner was served. I guess I've learned how to scavenge for supper after all.

Nantucket fun isn't limited to the summer months. The shoulder season (spring and fall) offers unlimited opportunities to experience the island. Recreational scallop season runs from October 1 to March 31. Make plans to come spend a long weekend or extended vacation on the island. Borrow, purchase or bring your own stylish waders, push rakes and shucking knives. Join dozens of other scallop enthusiasts in the beautiful waters around Nantucket and dig for dinner.

Aw shucks.

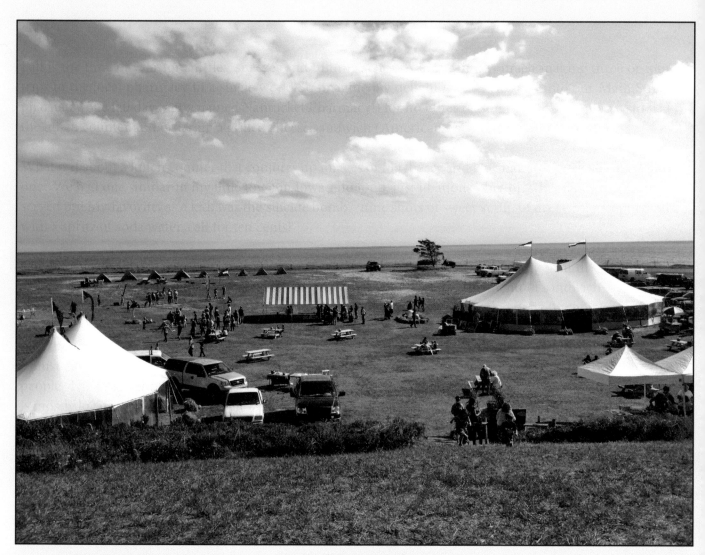

Nantucket County Fair

Fair Weather

There's nothing like the fall air on Nantucket. The change in temps brings with it the anticipation of a new season of island festivities. Whaler football games, scallop season and the annual Nantucket County Fair. I attended my first ever island fair out in Tom Nevers recently. I was reminded what the country group Lonestar has to say about the county fair. *"Down at the county fair...big time, big top, big crowds, big hair. There's nothing bigger all around...the country anywhere...than the county fair."*

I'm an Iowa girl and no stranger to county fairs. As a teenager, it was one of the biggest social events of the summer. An opportunity to dress up in your best Wrangler blue jeans, pull on your Frye boots and spend a couple days with friends eating funnel cakes, admiring blue ribbons and trying to impress the small town boys. I even tried my hand at County Fair Queen (I was a runner-up, Taylor County had a whole lot of "purdy girls"). Some of my best memories as a teen took place at the county fair.

The recent Nantucket Island Fair offered kids and adults the same opportunities for making great memories. There were similarities to my Iowa county fair. Livestock was presented (a wide variety of chickens, sheep and even a few piglets). Produce was judged (there were some HUGE peppers!) as was an assortment of food items (jellies, jams and baked goods). Live music took center stage both days. Fried dough and hot dogs were in abundance...as were the cute girls in their blue jeans (although it appears Wranglers are no longer in vogue).

There were some notable differences between Nantucket's fair and any other I've attended in the Midwest. The American Legion food tent showcased fried scallops, Quahog fritters, bluefish pate and littlenecks on the half shell. There was a scarecrow building contest, a surf-casting contest and a corn husking competition - one the announcer affectionately referred to as the "Shuck Off." Perhaps the most significant difference between our island fair and any other is the location. In my county in Iowa, the fairgrounds are located near several hundred acres of corn and bean fields. The Nantucket County Fair is held on a bluff overlooking the Atlantic Ocean. It was quite a scene.

It's never too late to plan a trip to the island to enjoy the fall festivities. If you've never attended the Nantucket fair, make plans now to bring your friends or family and join the fun this year. You too can build a scarecrow, throw a skillet or step right up for the Shuck Off.

Fair Enough.

Prescription for Happiness

Fall is the time of year for sniffles, sneezes and tummy aches. You can find yourself making three or four trips to the local pharmacy in a single week! So imagine my delight when I stopped into our Main Street pharmacy one fall day (aptly named Nantucket Pharmacy!) for no other reason than to slide onto a stool at the lunch counter and order up a grilled cheese sandwich (American on whole wheat thank you).

What is it about a lunch counter that conjures up images of Mayberry and Norman Rockwell all rolled into one? We had one similar in my little town in Iowa - no food, just libations - but oh what fancy drinks they served up! My favorite, as a kid, was the suicide bomb - nine shots of sweet syrup of every color topped off with a spritz of soda water - all for ten cents!

The Nantucket Pharmacy does not disappoint in the beverage department. Yummy fruit drinks, frappes and milkshakes, coffee and tea. Whatever your pleasure! And of course the menu of sandwiches is just as charming. Old-fashioned tuna melts, BLT's and homemade chicken or egg salad on your choice of healthy bread or rolled up in a thin wrap. They aim to please!

I must admit though, my favorite part of the lunch counter experience isn't the food or fun drinks, it's the people. The girls behind the counter are bubbly, warm and engaging. During the fall months the clientele is mostly locals - chatting about their holidays or their kids or the vacation they hope to take in March. We admire each other's sandwiches and inquire about how our days are going. Community at its finest.

I'm not a complete stranger to this charming place. I recall many summer days when my kids and I would stop in for a quick egg salad sandwich and an ice cream cone for dessert. In the summer months it's especially festive because there are so many people vying for one of those few coveted stools. But right now, in the "off season," it is filled with familiar faces and friendly chatter. Homegrown hospitality.

Whether you are considering dining options for your upcoming vacation or you are lucky enough to call Nantucket home, by all means don't wait until you are under the weather to pay a visit to one of the island's best-kept secrets...and discover a prescription for happiness!

Tuna melt or egg salad?

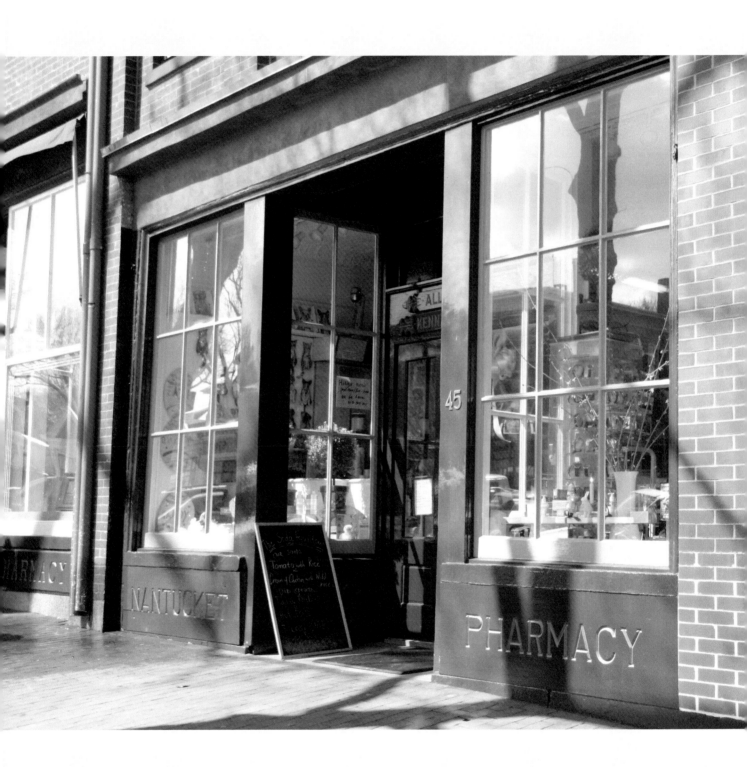

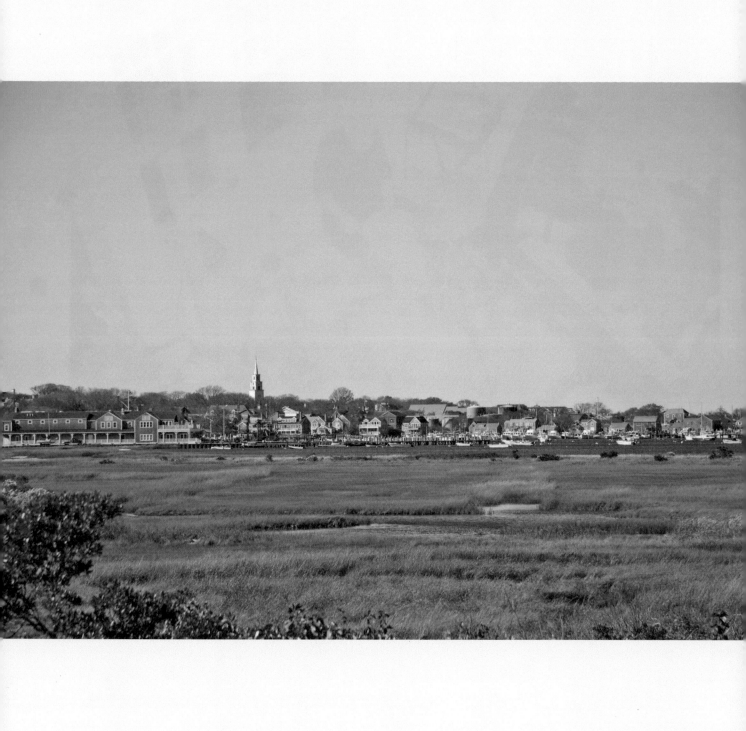

Indian Summer

In the fall, Nantucket stretches its arms, exhales a slow steady breath and prepares to kick its feet up after a jam-packed summer of gracious hospitality. One by one the leaves turn from green to red, orange and yellow. Temperatures cool, the crowds thin and it gets a bit easier finding a place to park. From my window I see sweaters and scarves replacing the beach wear and flip-flop attire of a few short weeks before.

I love every season on Nantucket, but after spending some time here as a full time resident, I can say that this time of year - Indian Summer - is my all time favorite. There's something special about watching the island ever so slowly wind itself down as the hustle and bustle lessens. Even as the pace slows, the beauty of the island seems to take on a new vibrancy. The sky and ocean are an indescribable color of blue. The warm colors of marsh grass and transforming foliage of trees provide a soothing backdrop for the brisk fall days.

I returned recently from a few days off island. As the ferry pulled around Brant Point I couldn't help but instantly notice the stark contrast to where I'd just been. Although the cities I spent time in had their own brand of beauty and charm, they were busy metropolises. I spent several hours in heavy traffic - cars honking and cutting each other off with impatience. I stood in countless lines while traveling, rode in crowded buses and elevators and with the exception of the group of friends I was with, recognized exactly no one in the shops and restaurants I visited.

During the segue into the Nantucket quiet season, the only honking I hear as we enter the harbor is another ferry tooting its horn announcing its departure...bidding Nantucket a friendly but brief farewell. There are no lines to stand in, no crowded buses to ride and in every single shop or restaurant I enter I see a friendly face and receive a warm greeting.

The colors may be changing and temps may be dropping, but the island hospitality is still in full bloom. There are numerous activities on the Nantucket fall calendar. Visitors can attend concerts, lectures or a theater production. There are garden and cranberry bog tours, gallery openings and birding festivals. Take a long walk through color-splashed conservation paths then stop by the Rose & Crown for a hot toddy and live karaoke. If you're on the island in late October, you can join the Halloween fun at several restaurants and get caught up in the ghoulish festivities during the annual Nantucket Halloween parade on October 31.

If you need an excuse to slip away from the busy-ness of life in the fall, make plans to come spend a few days (or weeks) on Nantucket. Bring your walking shoes, a camera and a good book. Plan to spend some time sitting on a bench watching the afternoon sunlight dance across the harbor. Take a bike ride out to Quaise or North Pasture and soak in the multihued scenery. Come let the island refresh you.

Fall back.

NOVEMBER

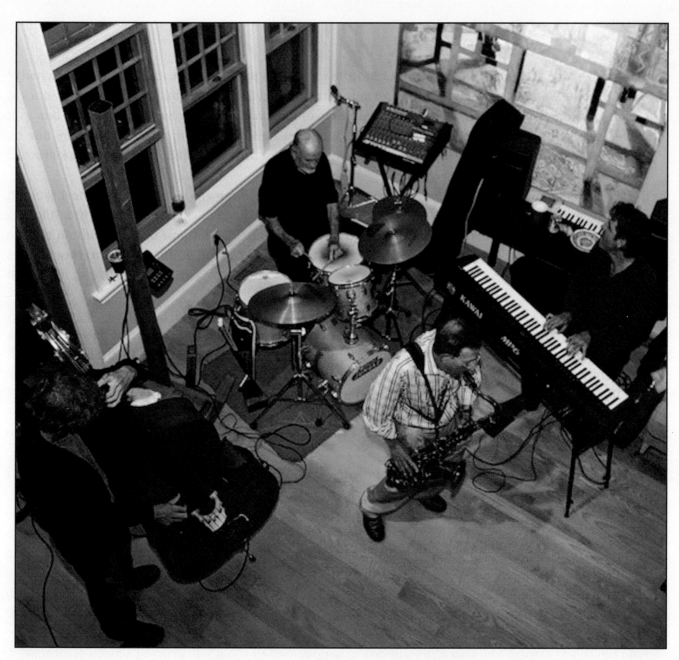

Photo courtesy of Susan Crehan-Hostetler

All That Jazz

It's no secret that Nantucket is brimming with talented individuals. The island is well known for its willingness to support and showcase its talent as residents and visitors are given the opportunity to develop and utilize their gifts. Artists specializing in sculpture, painting or jewelry-making are featured in galleries and art shows. Actors, directors and theater buffs take center stage in a wide range of productions throughout the year as part of the Theatre Workshop of Nantucket. Local authors and photographers capture the island's beauty and charm in novels, poetry and photo-filled books. I've recently become intrigued by another group of talented individuals - musicians. Jazz players in particular now command my attention and set my toes tapping.

I went with a group of friends recently to hear Matthew Hutchinson and his jazz ensemble in concert at the Congregational Church. I'm not a music aficionado, but I found myself completely enthralled by the notes, the rhythm and the musicians themselves. There's something about jazz that the performers "feel" not simply play. I was captivated watching their body language and facial expressions as the melodies commenced, picked up steam and ultimately reached their pinnacle while the walls of the church reverberated.

I have friends who are jazz players. I find them to be a rare breed. They communicate differently than me. They are in tune with their immediate surroundings, in sync with each other and intuitive in anticipating what their fellow performers will do next. One jazz friend, who's in his 80's, has convinced me that the way to finish life well is to spend every day doing what you love. The majority of his years have been spent creating art and playing music. Every time I see him poised at the drums, setting the tempo for his fellow musicians, I can't help but be moved by the huge smile on his face. Whether it's a ten-minute sit-in or a three hour gig, that childlike grin is his trademark. My friend and other jazz musicians have inspired me to explore my own passions, express myself and embrace the intricacies of life.

Chicago and New Orleans aren't the only places to tap into your inner jazz. While on Nantucket, stop in at the White Elephant and move to the beat of the Bob Lehman trio, attend a jazz concert presented by Nantucket Island Arts and Music (NIAM) or perhaps host a local dinner party where musical friends will opt for a post-dinner "jam session" to jazz up the evening. NIAM recently announced they are in the process of designing a Jazz Festival for Nantucket. Their plan is to bring some big jazz names to the island, while offering classes and symposiums for all ages and abilities in an effort to make Nantucket a Jazz Festival destination spot. No firm dates have been set yet, but keep an eye on their website and then make plans to come be part of Nantucket's jazz scene. Bring your own instrument, take a lesson or simply grab a seat alongside some other music lovers and spend the evening swaying to the rhythm.

Get jazzed.

'Sconset Sunrise

When the clocks roll back an hour in the fall it gives most of us in the country one extra hour of daylight. My internal clock doesn't adjust too easily, so I often find myself wide awake at 5:00 a.m. Rather than toss, turn and count six hundred sheep in an attempt to grab a few more winks, I decided one morning to jump up and embrace the early pre-dawn hour. I poured a steaming thermos of Nantucket Blend, grabbed a fleece jacket and jumped in the Jeep with Coco the white dog to head east.

Because Nantucket lies twenty-two miles out to sea and is one of the easternmost points in the U.S., it's one of the first places in the country to experience daybreak. I park the car in Codfish Park, spread my blanket on the sand and wait for Mr. Sunshine to rise up and greet me. There is something very surreal and empowering about sitting ocean-side at the crack of dawn, knowing you're one of the first people in the nation to welcome the day.

As I sip my java in the wee hours while beholding the vast body of water before me, I consider this quaint seaside 'Sconset Village. I think about the generations of folks who have watched with anticipation for the first break of daylight. A sea captain's spouse or children spanning the horizon, hoping for a glimpse of their loved ones vessel returning home. Fishermen anxious to assess the sea conditions as the sky illuminates. First time Nantucket visitors greeting the new day from their bluff-top rental home. I wonder if all these 'Sconset dwellers experienced the same awe I feel as the large orange ball slowly appears and ascends up over the sparkling Atlantic Ocean.

I love a good sunset...especially on Nantucket. From virtually any vantage point on the island you can watch the sky turn a dozen different colors as the day draws to a close. Sunsets are romantic and have the ability to enrapture onlookers, inspire a toast and in some cases command a round of applause. Watching the sunset causes us to reflect on what's been, celebrate the day's successes and put to rest those things we wish had been a bit different. A sunrise prompts different emotions. It generates feelings of hope, anticipation and excitement. It reminds us we get a do-over if we blew it the day before or an opportunity to stay the course if previous days had us on a good path. It motivates us to look forward, not back and compels us to make the most of the hours ahead as sunset will arrive much too soon.

A Nantucket sunrise in particular holds its own unique possibilities as a new day dawns. The island offers countless opportunities to surprise and delight its guests - a rare bird is spotted in Madaket, a whale breeches on the horizon off Tom Nevers, a small catboat glides across the water in Dionis. As I watch the sky begin to brighten, I'm filled with the anticipation of a child on Christmas morning. I ponder the magic of the island and the yet to be discovered secrets it has in store for today. Some morning soon, why don't you make a plan to greet the new day with a Nantucket sunrise? Fill your own coffee thermos, head east to 'Sconset and let Nantucket bid you good morning.

Rise and shine.

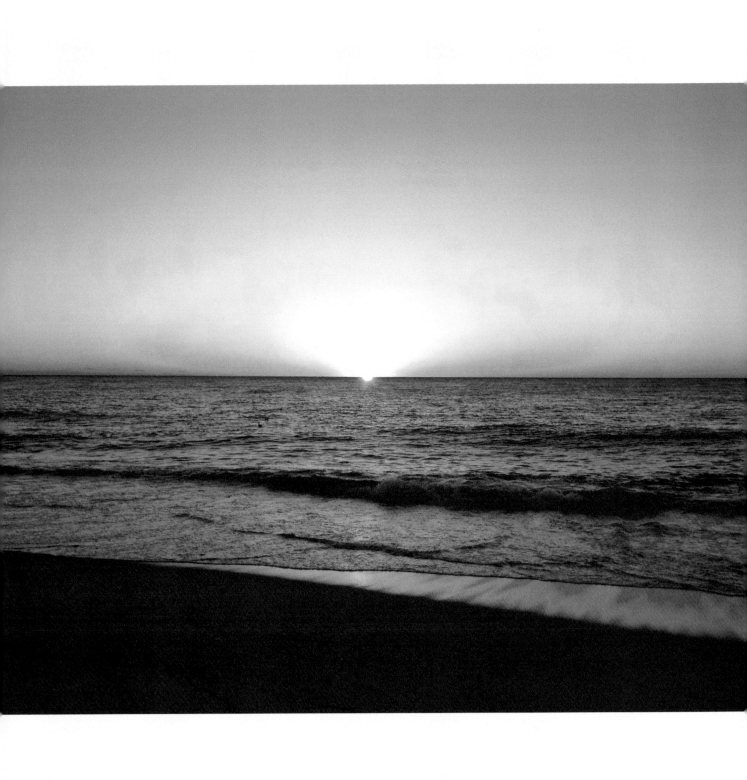

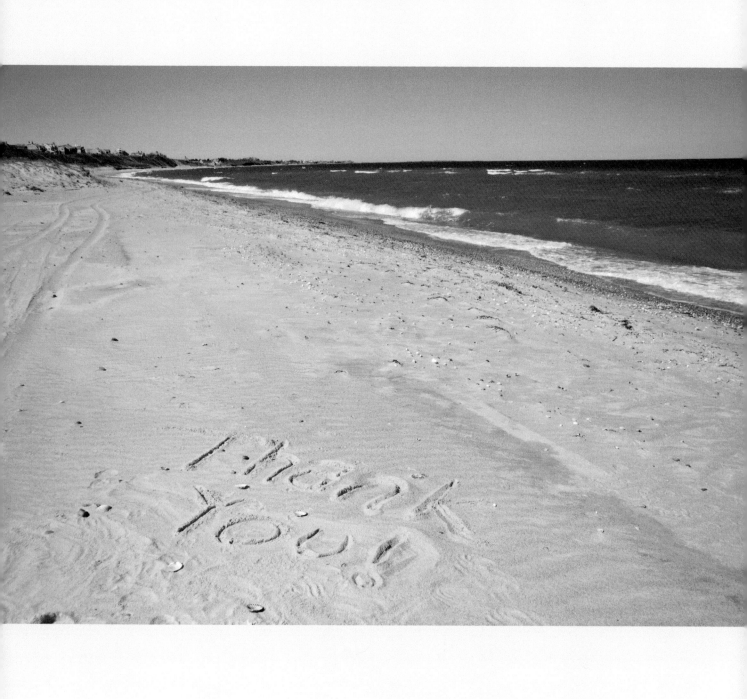

Gratitude

Periodically, temperatures can hover in the high 50's and low 60's in mid-November, making it hard to believe Thanksgiving is already upon us. It can seem like just yesterday we were winding down our beach days. I hear it everywhere I go - time is flying by. As a kid, I always heard my grandmother say that as you get older time speeds up...I must be getting old because time feels like it's on a bullet train.

I'm finding it takes conscious intention to slow the pace down and make time each day to thoughtfully consider the things in life that really matter. Nantucket provides the picture perfect setting for this contemplation. Sitting on a harbor-front bench, walking alongside the ocean at one of the islands many beaches or simply pausing at the top of Main Street on a quiet autumn evening, I find I can inhale a giant gulp of fresh ocean air and think of a dozen things to be grateful for as I exhale.

As I sit and gaze out my office window on a rainy fall day, I find myself grateful to live in a place that's a bit removed from the rest of the world. People stop to chat on the sidewalk outside, the remaining leaves slowly tumble from their branches, and window boxes are adorned with pumpkins, gourds and baby squash in preparation for the upcoming holiday celebration. I'm grateful to live in a peaceful storybook setting. I'm thankful for friends and neighbors willing to crawl into the trenches on the tough days and gather around the dinner table to toast the good days. I'm reminded to give thanks for the big things - good health, happy well-adjusted kids and grandkids and pockets of time to spend with all of them. Appreciative to have a job...and co-workers, colleagues and clients who make it fun to come to work each day. Very lucky to have a spouse who makes me laugh and still calls me his best friend after twenty-six years. Thankful too for the little things - a walk on the beach at Cisco, a Nantucket starlit sky, the birds chirping good morning just as the day dawns.

Thanksgiving week gives all of us the opportunity to pause and reflect on the good things in our life, to gather with friends and family to celebrate these blessings and to prioritize what's important. I'll bet you have a long list of your own reasons to be grateful. I've heard numerous stories from clients and friends over the years about surviving cancer and overcoming illness, relationships being healed and new jobs being secured "just in time." This time of year reminds us that anything is possible.

As you gather with your friends and family to celebrate Thanksgiving, be sure to slow the pace down and raise a glass to our beloved Nantucket. Recall fond memories shared with friends and loved ones, enjoy a few good laughs and celebrate your own Nantucket Experience.

Give Thanks!

Takin' The Plunge

What prompts a few hundred men, women and children to shed their outerwear and run headlong into the frigid Atlantic Ocean on Thanksgiving morning? More than a few spectators were likely asking this very question on a bitter cold Thursday as they gathered on Children's Beach to watch the Tenth Annual Cold Turkey Plunge. Perhaps it's the thrill of the instant numbing effect as the icy water meets warm human skin? Maybe it's mob mentality (mom, everyone is doing it!) Or maybe it's just the delight that occurs when you join a group of friends and neighbors for some good clean fun. Whatever the reason, this event has become a Nantucket holiday tradition.

One of my favorite things about the people of Nantucket is their willingness to let their hair down and find creative ways to commemorate special occasions. They don't do anything halfway...they go all out. It's not enough to simply plunge into ice cold water; Nantucketers choose to do it in style. Participants arrive at the Cold Turkey Plunge event in elaborate holiday costumes, fluffy designer bathrobes and silly themed swim-caps. A real life Tom Turkey, smartly clad in his holiday bow, struts about on the lawn clucking and gobbling as he delights onlookers and poses for photo ops. Young and old alike are bright-eyed and exuberant with holiday spirit.

The Cold Turkey Plunge is sponsored by the Nantucket Atheneum to raise money for the Weezie Library For Children. The island is famous for rallying residents and visitors around a common cause where others reap the benefits. I'm always struck by how these types of events are a "win-win" for all involved. The sponsoring organization raises much needed funds and participants are given an excuse to gather with friends and neighbors, do something a little outrageous and have some good old-fashioned fun...all for the common good.

When on Nantucket, be sure to peruse the "upcoming community events." Chances are you'll discover an event where you have the opportunity to participate in something meaningful, something philanthropic or perhaps just something downright silly. Whatever the activity, you can count on making some memories, meeting some fun people and broadening your horizons.

Dive in!

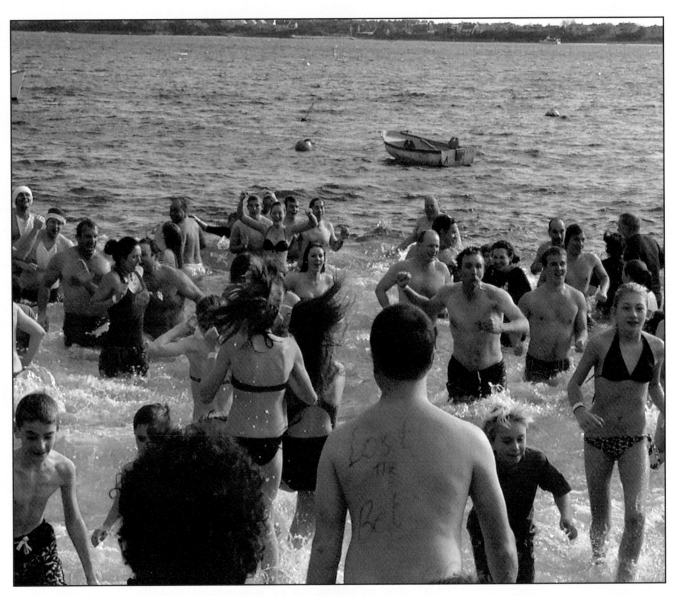

Annual Cold Turkey Plunge on Children's Beach

DECEMBER

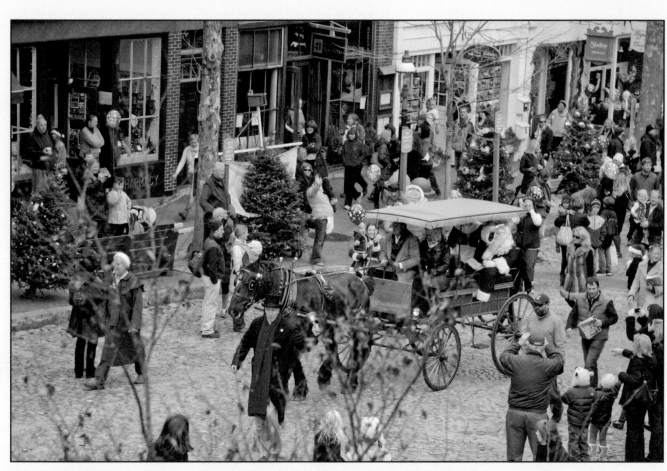

Annual Nantucket Christmas Stroll Weekend

Strollin' Along

The first week in December, it begins to look a lot like Christmas - everywhere you go on Nantucket! The kids come out en masse to decorate all the trees on Main Street. Entire classrooms from the Nantucket Schools descend on downtown, arms laden with decorations. The children can hardly contain their enthusiasm as they take their turn adorning their respective trees while singing Christmas Carols at the top of their lungs. From my second story Main Street office I hear the sounds of Jingle Bells ruminating from the street below. It makes me smile...and makes me wonder who the Scrooge was who made the rule that once you become an "adult" you can no longer scream Jingle Bells from the rooftops when you're bubbling over with holiday enthusiasm?

The festive spirit continues into the weekend as the official holiday season is kicked off with the annual Nantucket Christmas Stroll. The island bursts with weekend guests, decked out in their holiday attire, Santa hats and reindeer ears. Anticipation swells Saturday morning as throngs of people follow the Town Crier to Straight Wharf to await the arrival of the Coast Guard boat delivering Mr. and Mrs. Claus. Boys and girls, moms and dads and scores of curious onlookers vie for the perfect spot to catch a glimpse of the white bearded jolly fellow and his bride. Some lucky attendees get to shake his hand and sit on his lap.

Like over-anxious kids on Christmas morning, holiday revelers take to the Nantucket streets bright and early on Friday and continue their shopping, dining and jovial socializing through the weekend. There is a myriad of holiday activities to choose from ranging from browsing at the Christmas Market in the Grand Union parking lot to attending the Christmas Stroll Craft Show. Visitors meander through the Festival of Trees, get a sneak peek into several of the islands most beautiful homes during the Holiday House Tour and have the opportunity to skate with Santa at Nantucket Ice. Several art galleries have openings, St. Mary's features a Christmas Bazaar and St Paul's showcases dozens of crèche scenes in their "No Room at the Inn" display. There is no shortage of entertainment during the weekend. Live musicians are strategically stationed at various locations throughout the island causing onlookers to hum along or break into song with their favorite holiday carol. You can enjoy a presentation by Theatre Workshop of Nantucket, a Christmas Stroll Opera Gala by Nantucket Island Arts and Music or a live reading or concert at the Atheneum.

If you miss the Christmas Stroll festivities, it's never too late to experience the holiday spirit on Nantucket. Many of the exhibits, local retail sales and restaurant specials continue throughout the month of December. Usher in the holidays in Nantucket's Charles Dickens style setting.

'Tis the season.

Won't You Be My Neighbor?

Fred Rogers once said, *"When I was a boy and I would see scary things in the news, my mother would say to me, "Look for the helpers. You will always find people who are helping."* I had the pleasure of meeting Mr. Rogers in person several years ago. Our son Drew was just a little guy. It was a warm summer June day and we had just stopped at the pharmacy for an ice cream cone – a double scoop! We rounded the corner on Federal Street and ran head on into the man my son had grown up mesmerized by each morning. He wasn't hard to recognize – not only did he look exactly the way he did on television, but he was outfitted in his famous red sweater and tennis shoes – a sight to behold! As Drew avoided a near collision with him, Mr. Rogers chuckled and touched his elbow. "Whoa there young man", he said with a twinkle in his eye. "That ice cream won't do you any good on the sidewalk." He proceeded to enlighten us with the many wondrous benefits of ice cream. He exuded everything good about humankind…kindness, gentleness and a genuine interest in his neighbor. It was a day for the memory books.

Over the years, it has been easy to mistake Nantucket for Fred Rogers "Neighborhood of Make Believe." It's famous for its beautiful homes, pristine beaches and endless activities. But it is no surprise that at the core of all that makes Nantucket magical are the generous people of this island…our neighbors.

Last week, my husband opened our front door at 7:30 at night to find our neighbor John presenting us with a "just baked" coconut/banana cream pie. No reason…just because. Once last fall, our friend who is a local fisherman showed up on our doorstep with an armful of fish…just because. I hear these stories of neighborly kindness and generosity over and over again.

During the holiday season, the generosity is especially evident as island individuals and organizations band together to make a difference in the lives of their neighbors. The yuletide spirit is alive and well as islanders fill the food pantry, deliver meals on wheels, purchase secret gifts for neighbors in need and give generously to a variety of charitable organizations. If Mr. Rogers were alive today he would have no trouble spotting "helpers" on this fine island. And he would likely say to each one of them "I've always wanted to have a neighbor just like you!" Well done Nantucket.

It's a beautiful day in the neighborhood.

Good Neighbor John O'Connor

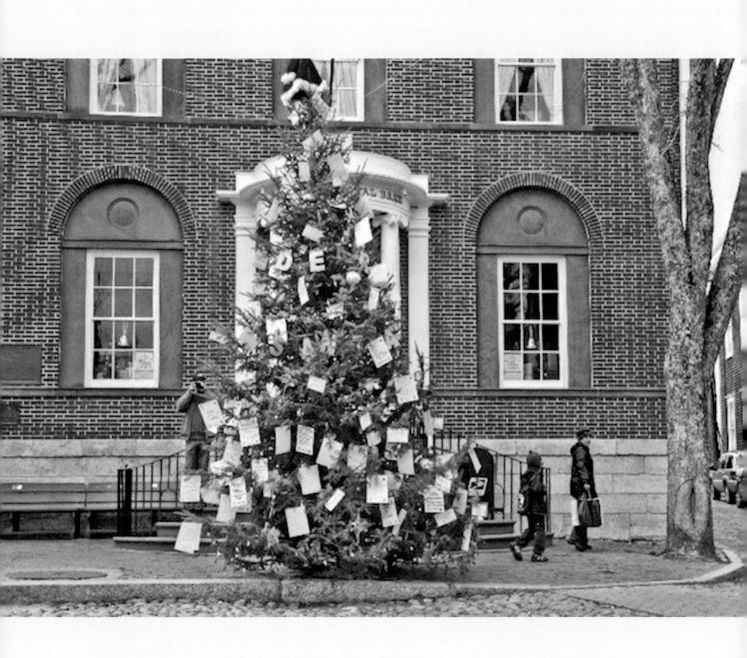

Make A Wish

One of the sure signs the holiday festivities are in full swing is the giant Christmas Tree perched at the top of Nantucket's Main Street beckoning visitors to gather 'round and embrace the season. Recently, the theme of the tree was "Dear Santa." Topped off with a Santa hat, it was aptly decorated with "ornaments" which were real-life letters to Santa written by Nantucket school kids. This was not your average holiday sapling... this tree was magical. At scheduled times, the tree actually "talked" to curious boys and girls anxious to make their holiday wishes known. I envy the volunteer hidden away behind the walls of the Pacific National Bank who gets to participate in this sense of wonder that defines the holiday season.

I chuckled as I perused the various "ornaments" hanging from the tree. There is something awe-inspiring about viewing this time of year through the eyes of a child. Their wish list to Santa revealed a lot about their personalities. Lindsay is an animal lover - she wants a kitty and a new horse. Becky, the humanitarian wants Santa to bring food for all the hungry people. Scott is practical...he's wishing for socks - that's all just socks. Crime-fighting must be on Ron's agenda - he wants UGG's, a cape and a magic wand. Steven, Kelly and Amanda are all about fun and games - their lists include board-games, a new bike and a hula-hoop respectively. Shelby dreams big - she's wishing for a private jet. Victoria is a girl after my own heart. Her list included love, health, happiness...and a diamond ring. Why not? It's Christmas after all.

I think it's true (or it should be) that Christmas isn't just for kids. I love seeing grown men and women walking up the street in their Santa hats or driving around town with reindeer ears on the hood of their cars. I'm not sure at what age we begin modifying our wish lists. While "grown up" issues are very real...and most times not very pleasant...this is the season when we're given permission to tap into our "inner child." We can hope for the best, wish for the seemingly impossible and believe in a miracle or two.

So how about you? What's on your list during the holiday season? Maybe you're a big dreamer like Shelby and you're wishing for a Nantucket vacation or your very own Nantucket summer home. Perhaps you're like Scott and you'll be happy as a Nantucket clam with warm new socks under your tree. If you're like me, there's no question a little love, health and happiness are in order. But like Victoria, there's no harm in wishing that something sparkly might appear under the tree as well. Whatever is on your list this year, be sure to write it down and put it where the jolly bearded fellow will find it.

Dear Santa...

'Twas The Night Before Christmas

I'm not sure whether it's the beautiful decorations lining the streets of downtown Nantucket, the dropping temps outside or the thinning crowds as the quiet season sets in, but when I step on to Main Street in late December, I feel like I've walked into a private winter wonderland. The setting looks like it came right off a Currier and Ives Christmas card. The atmosphere is festive, but quiet. Some nights there are no cars on the street and not a creature is stirring.

These nights remind me of our family's first Christmas celebration on the island. It was the early 1990's, soon after we'd purchased our Nantucket home. We decided it would be fun to experience the island in the off-season and the kids were excited to hang their stockings by a new chimney with care...and definitely hoping St. Nick could find his way there. We celebrated the holiday in true Nantucket style. We joined a few hundred enthusiastic locals on Main Street late in the afternoon on Christmas Eve for the annual Red Ticket Drawing. After a candlelit Christmas Eve service, we dined on the famed beef wellington at The Woodbox. Once the kids were nestled all snug in their beds, the cookies and milk strategically placed where Santa could find them and grandparents comfortably settled in front of the crackling fire, my husband and I decided to take a walk downtown.

It was a Nantucket night to remember. As we walked the six blocks to downtown, the fog began to slowly roll in and a chill filled the air. During our stroll, we didn't see another human being. As we rounded the corner from Liberty to Main, the scene before us was magical. Dozens of trees adorned with twinkling lights lined both sides of Main Street. We stood on the steps of the Pacific National Bank and took in the wonder of it all. The foghorn moaned in the distance as the thick white blanket crawled up Main Street and added to the mystique of the evening. When we finally spoke, we whispered. There wasn't a soul around to hear us, but it seemed sacrilegious to interrupt the moment with noise. Sometimes, words just get in the way.

Wherever you find yourself during the holiday season, I hope you have an opportunity to take a quiet stroll with someone you love. If you're lucky enough to be on Nantucket any time during the holidays, I highly recommend a late night trip to the top of Main Street. Admire the thoughtful and festive décor, send up some good wishes for your friends, family and neighbors and embrace the silent beauty of your surroundings.

<div align="center">And to all a good night.</div>